STEAMPUNK ANIMALS

A MECHANICAL COLORING ADVENTURE

This book belongs to:

Copyright © 2019 Steve Turner (alias Squidoodle).
The rights of Steve Turner (Squidoodle) to be identified as the illustrator of this work has been asserted by him in accordance with the Copyright, Designs and Patents Act 1988.
All rights reserved, including the right of reproduction in whole or in any part in any form.

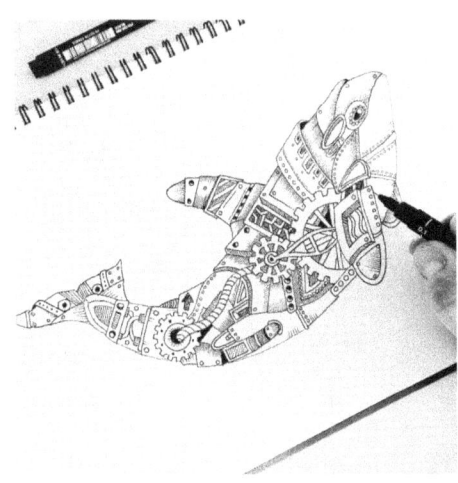
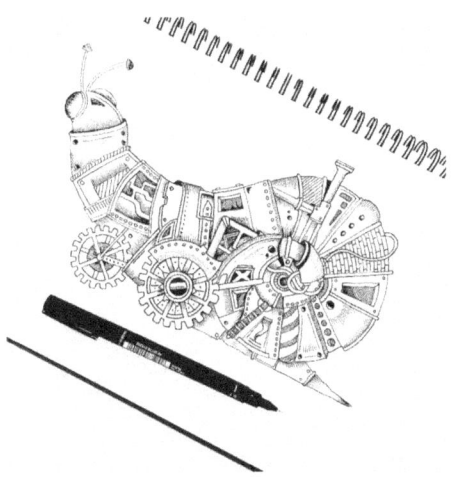
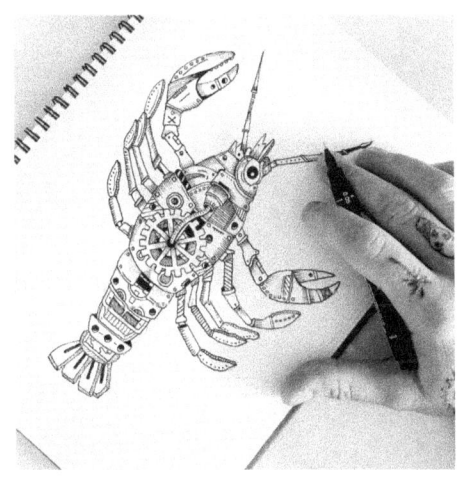

Yo! Thanks for buying this book!

I'd go so far as to say as this **should** have been my first ever coloring book. Drawing steampunk style animals has been my thing for years. I didn't, however, think I had it in me to produce a whole book of them until now. As it is, this is probably my eleventh? Twelth? I dunno. I forget how many I've done now. The idea is quite simple and probably comes from a lifelong love of mechanical things, cartoons, science-fiction and fantasy, alongside a love of all animals. I love drawing cogs and gears and metal armour, so applying this to animals makes for a fun twist on the adult colouring theme. Just think of all those lovely rusty browns and striking metallic colours you can use when you colour these animals!

I do hope you enjoy colouring this book as much as I enjoyed creating it. As with all my books, this one is dedicated to the two little people who are my inspiration, my biggest fans, my harshest critics, my helpers when sending out prints, my best friends and my best ever creations. **Poppy and Lola,** this one's for you.

XXX

Don't forget, for regular giveaways, updates, stupid videos and so much more, follow me online!

www.facebook.com/SquidDoodleArt
www.instagram.com/squidoodleart

....and for limited edition prints and downloads, visit my website:

www.squidoodleshop.com

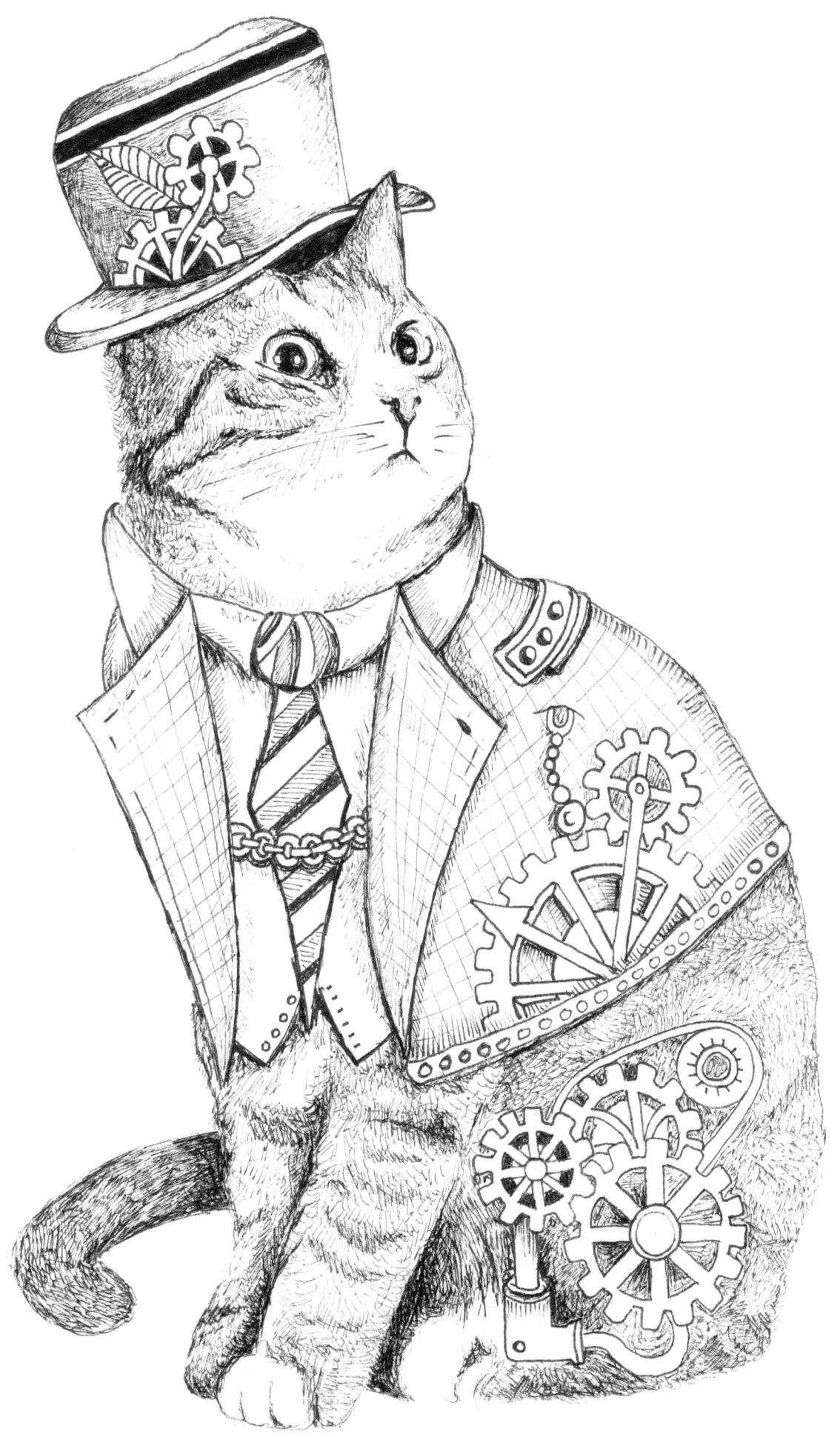

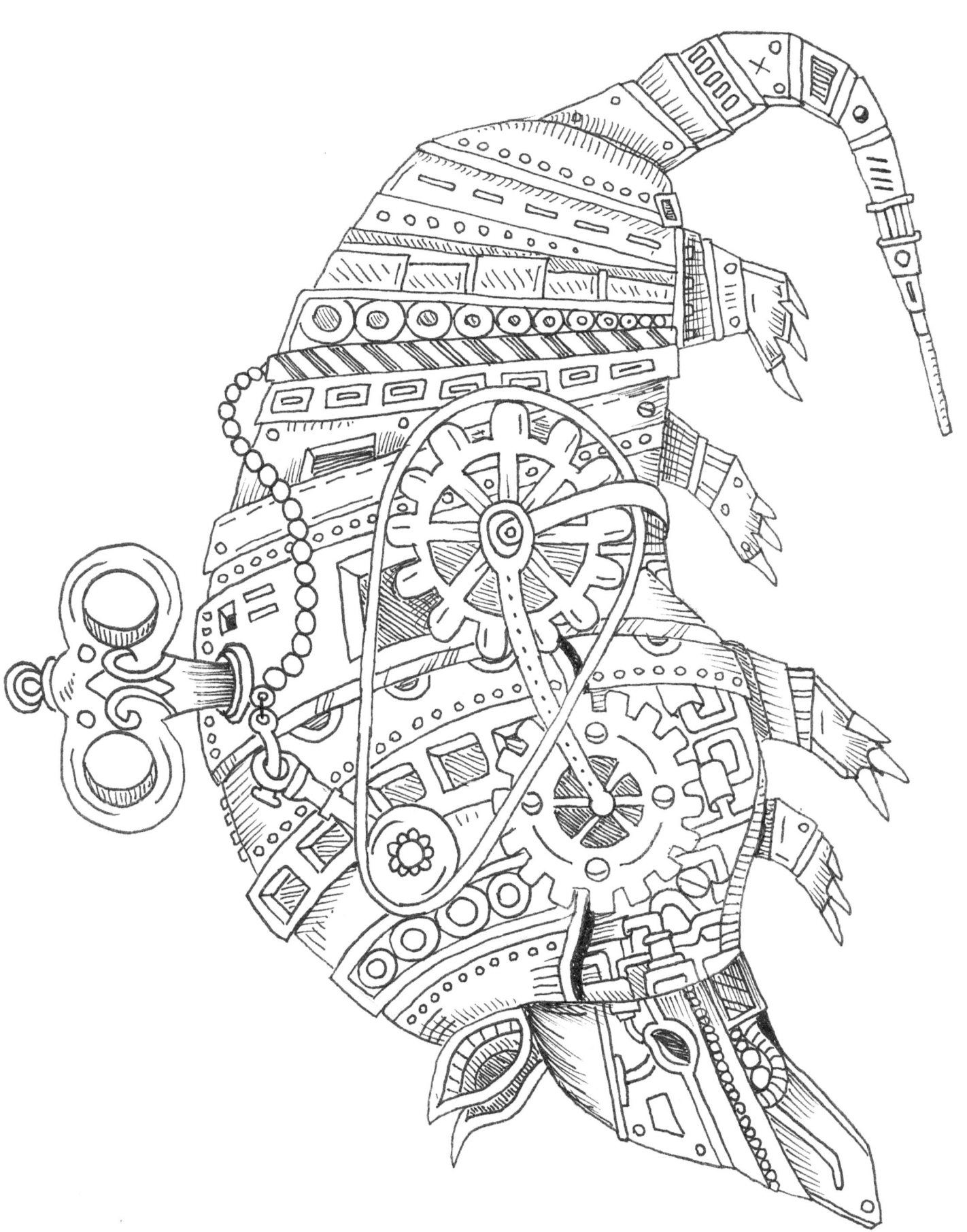

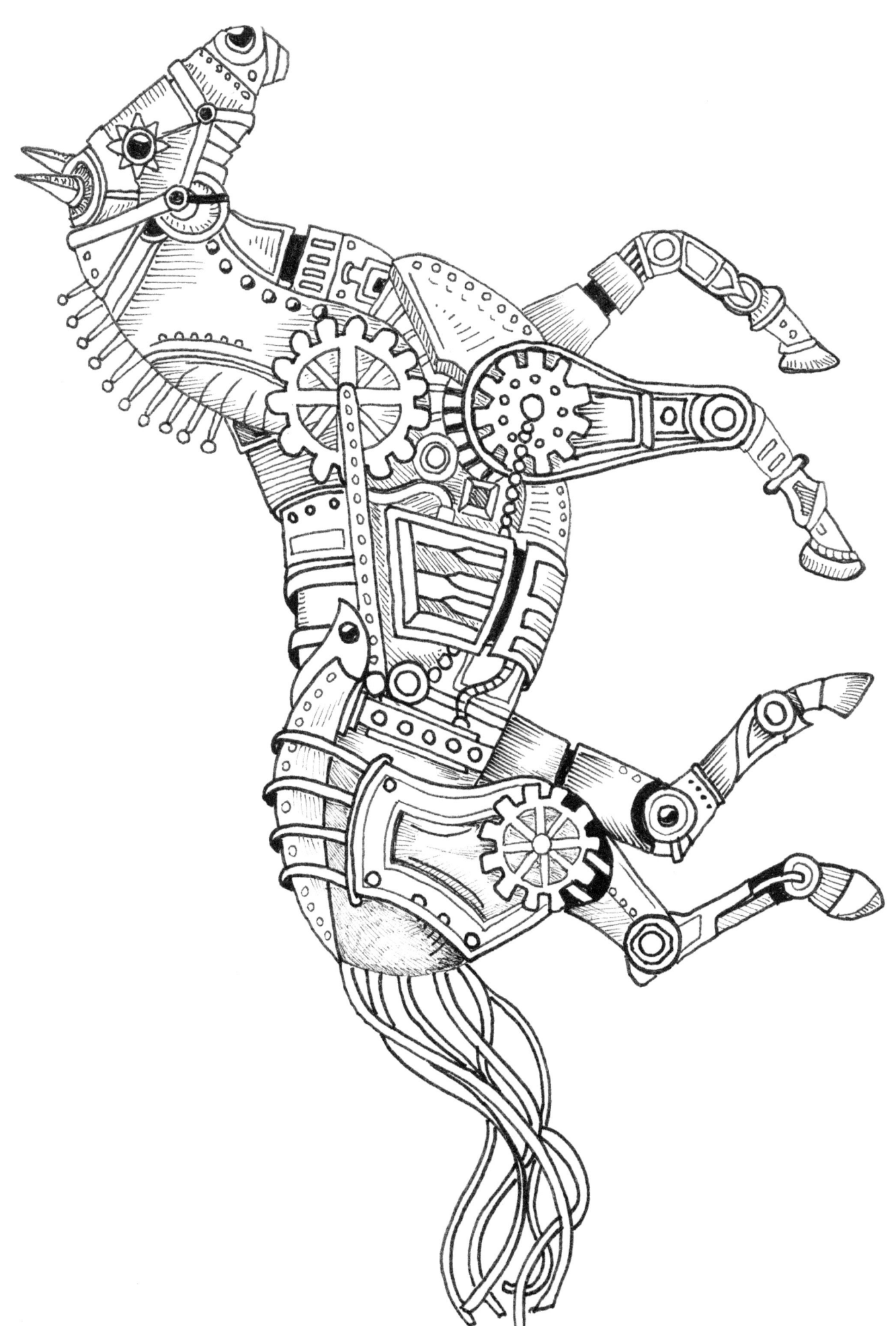

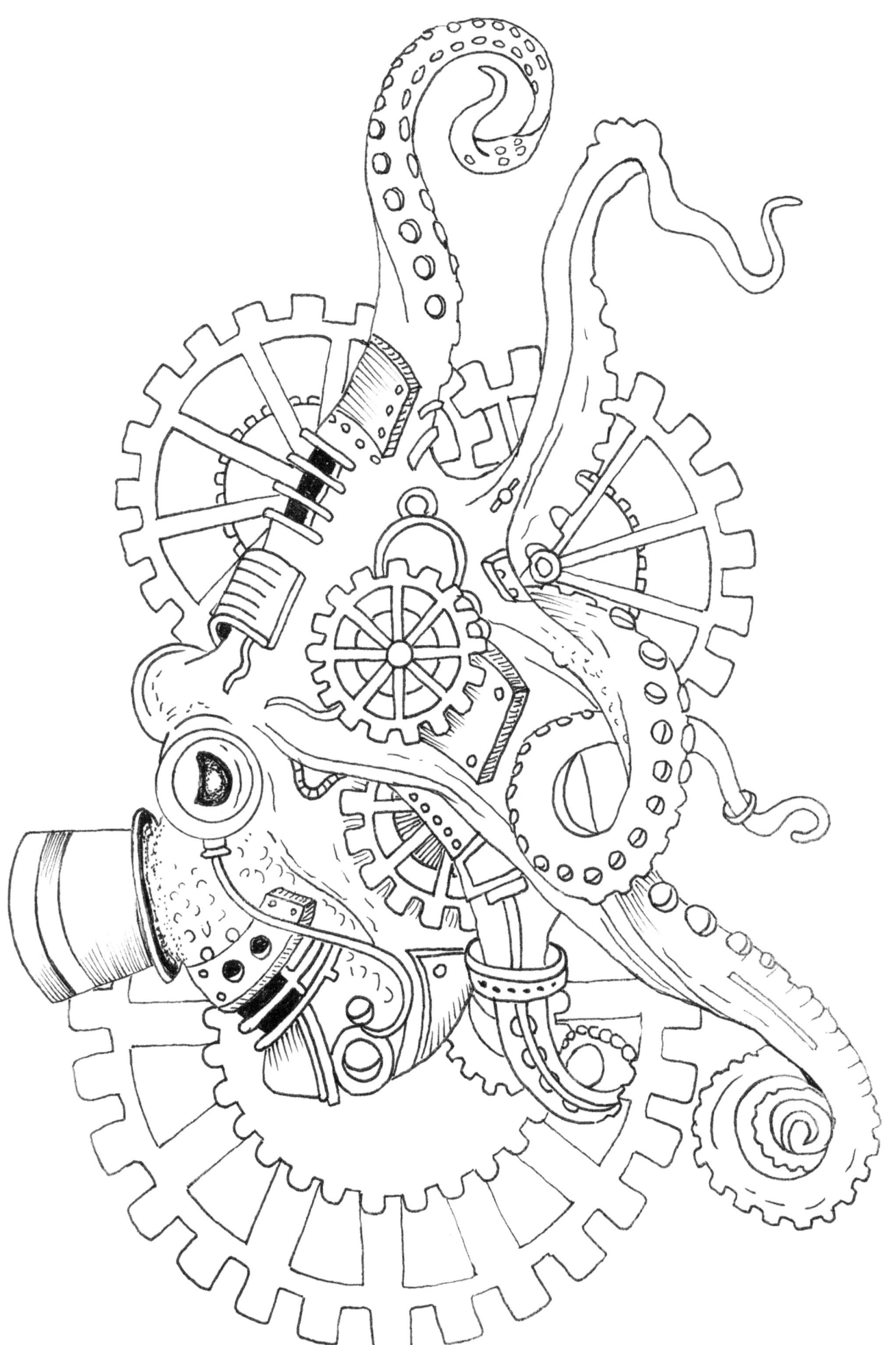

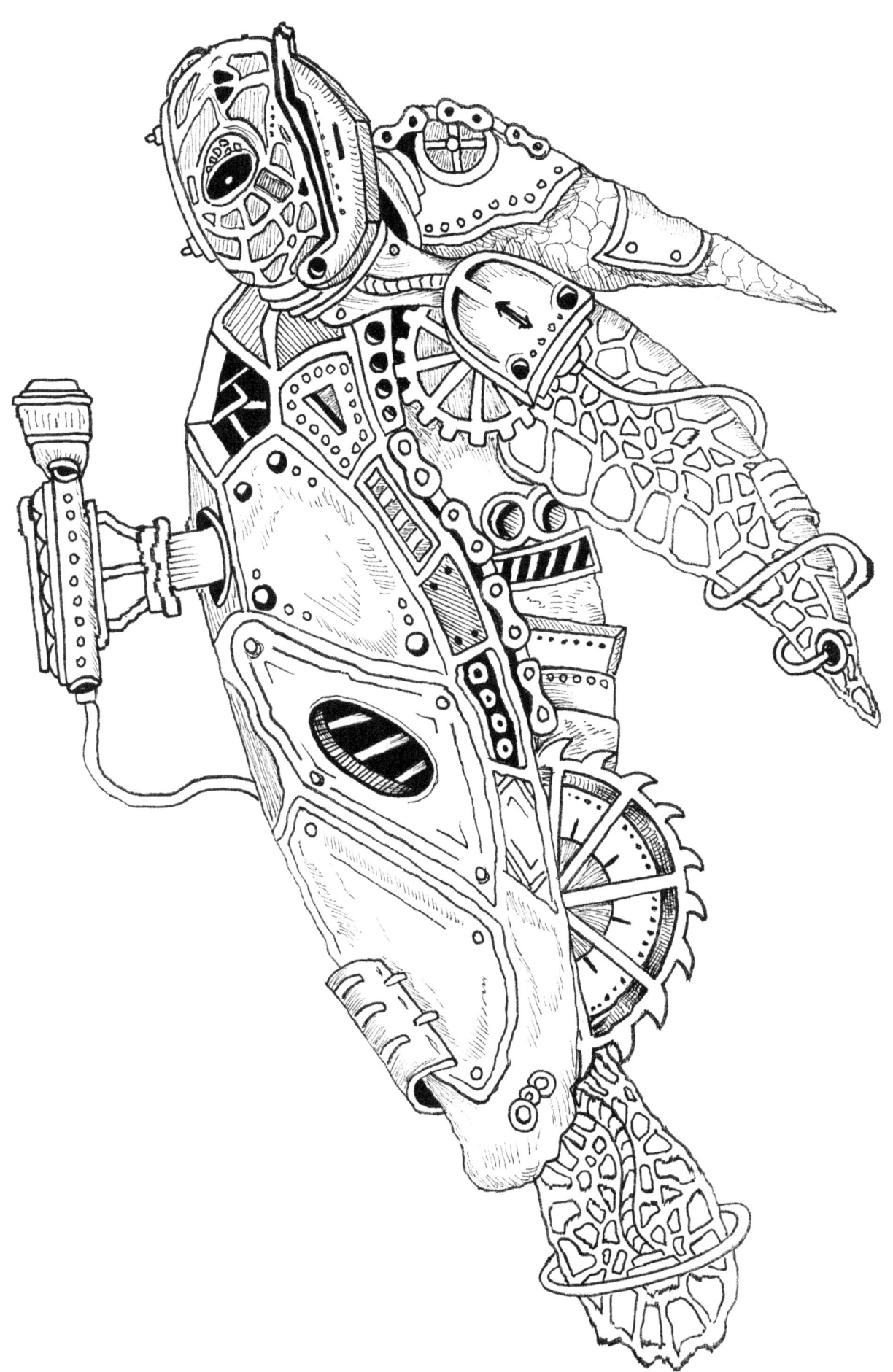

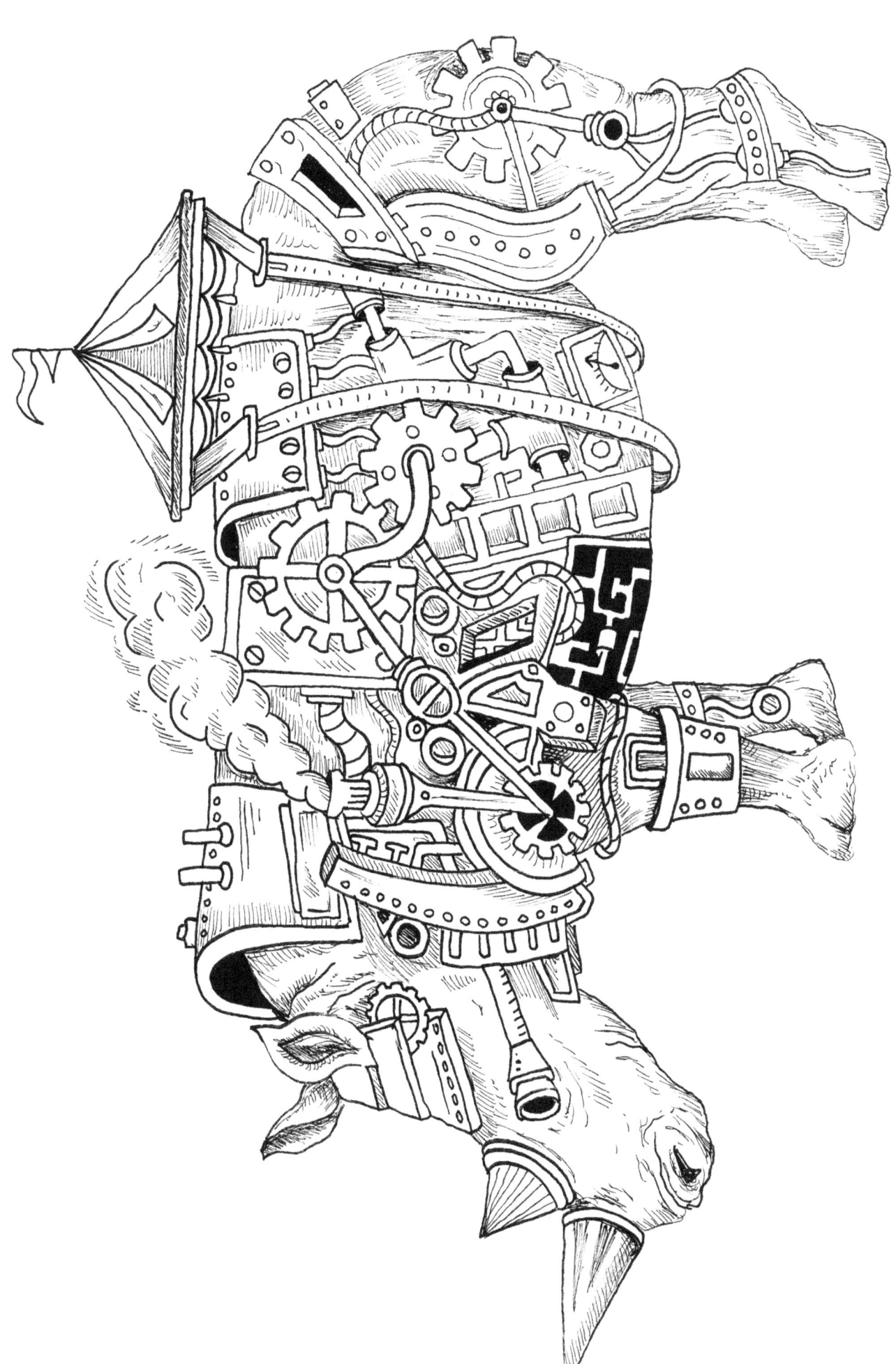

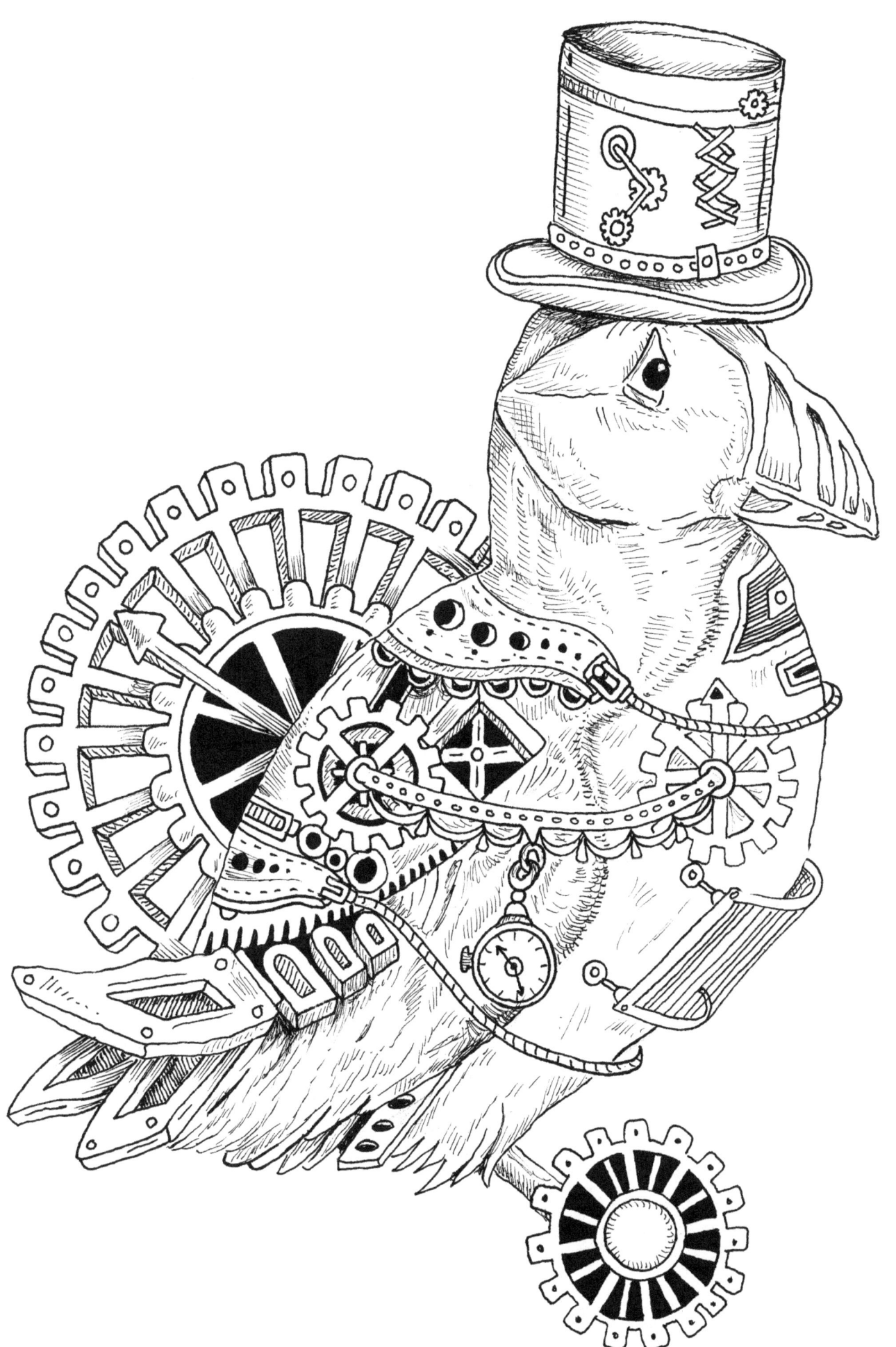

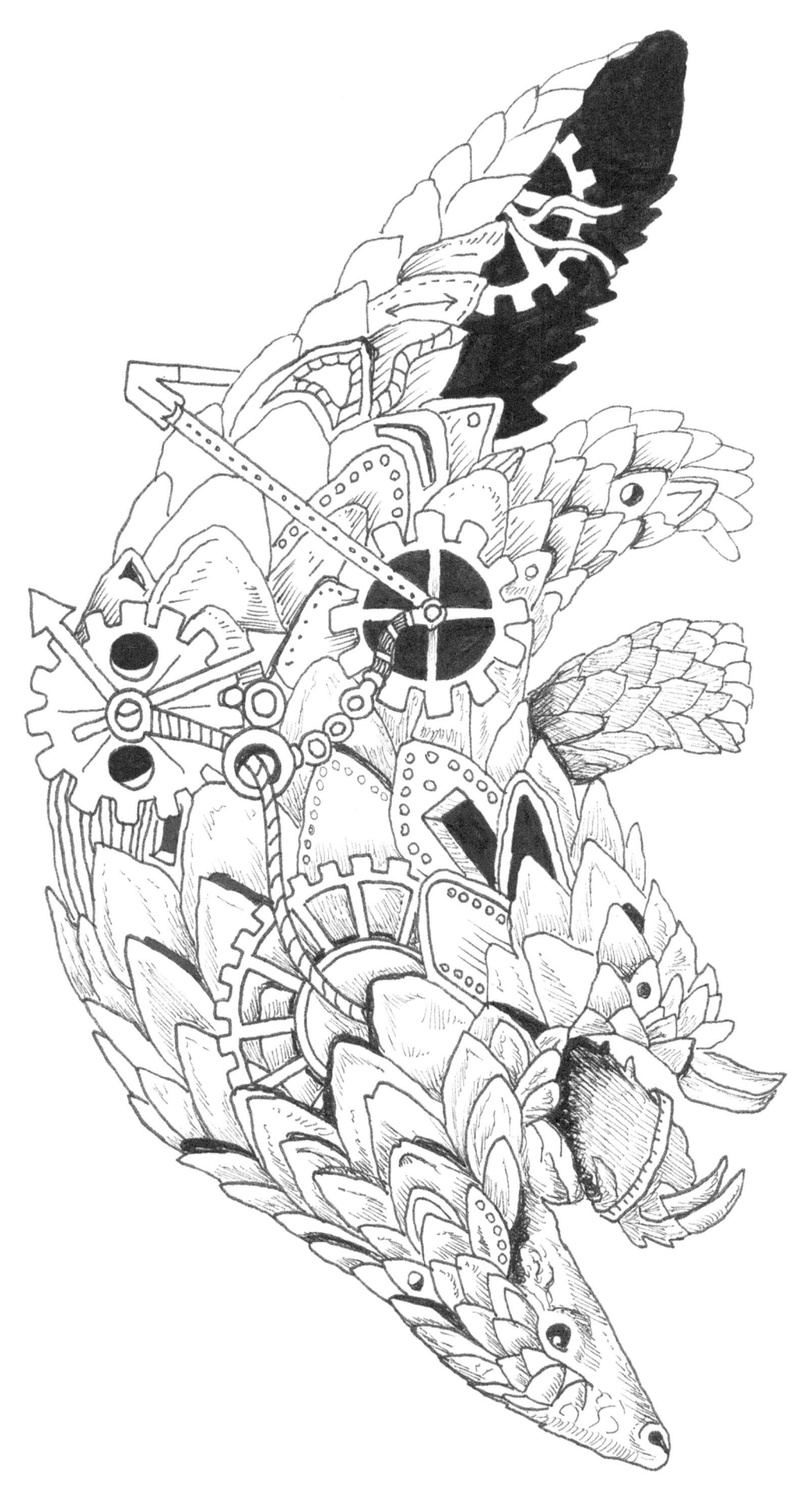

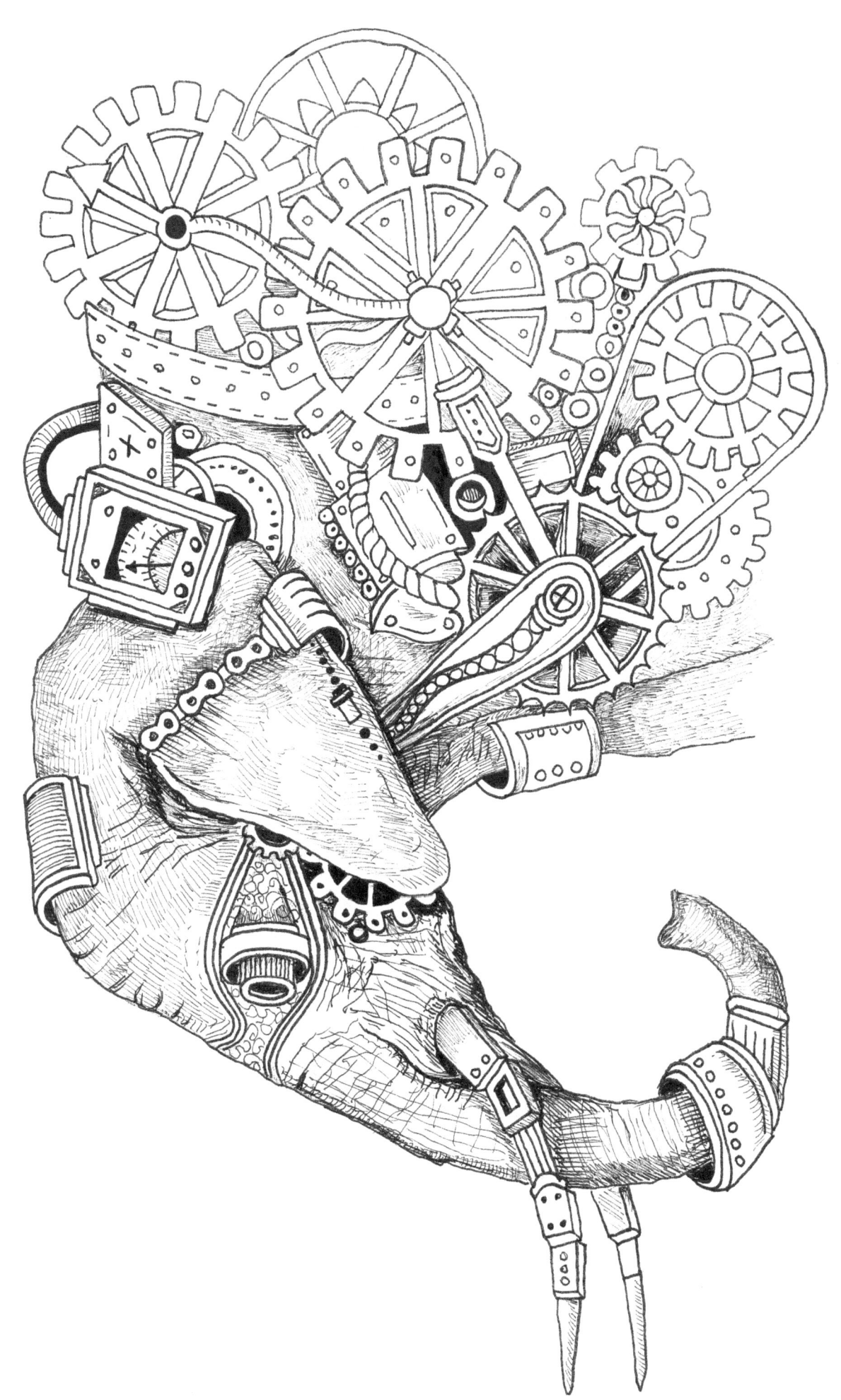

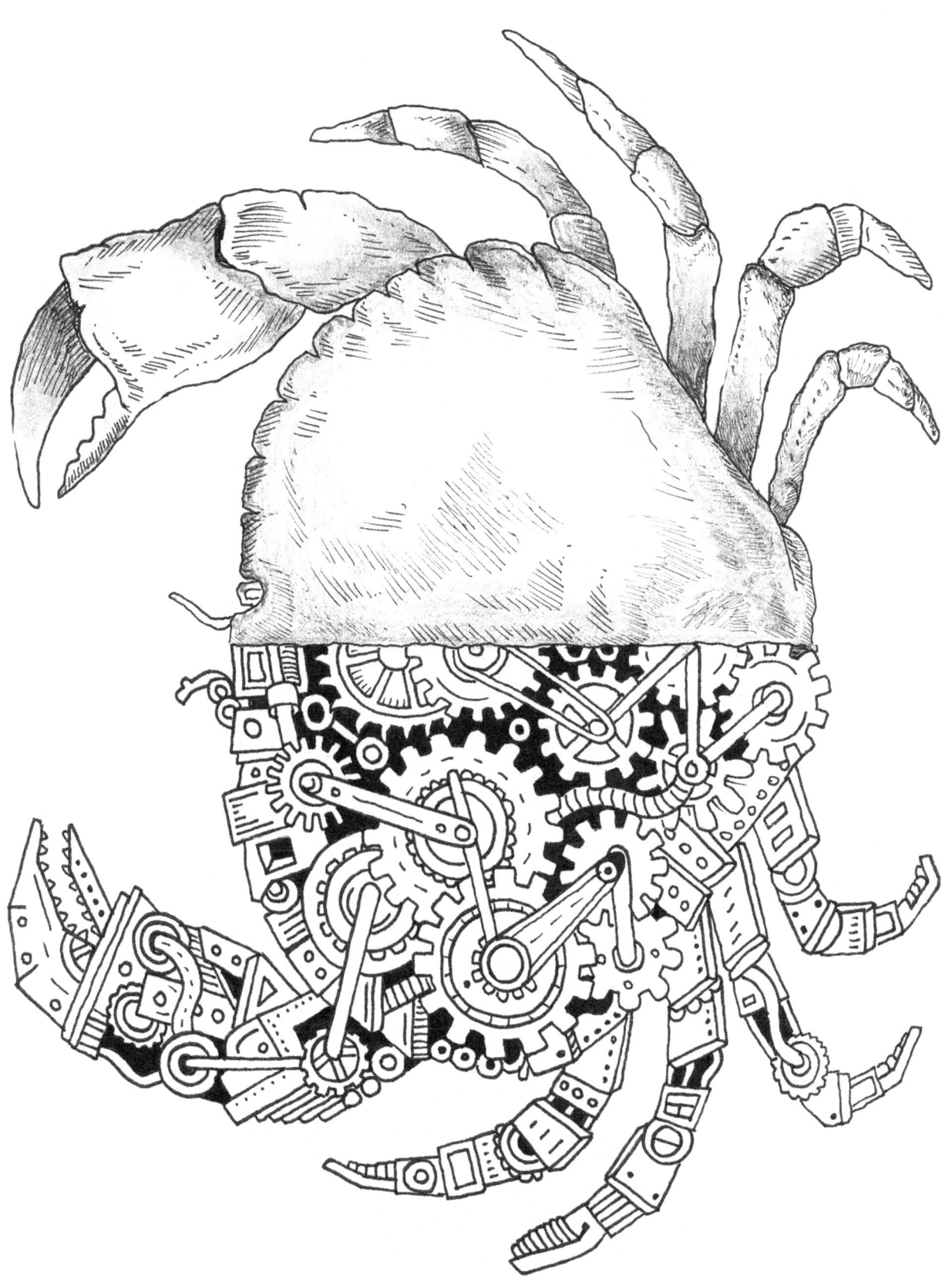

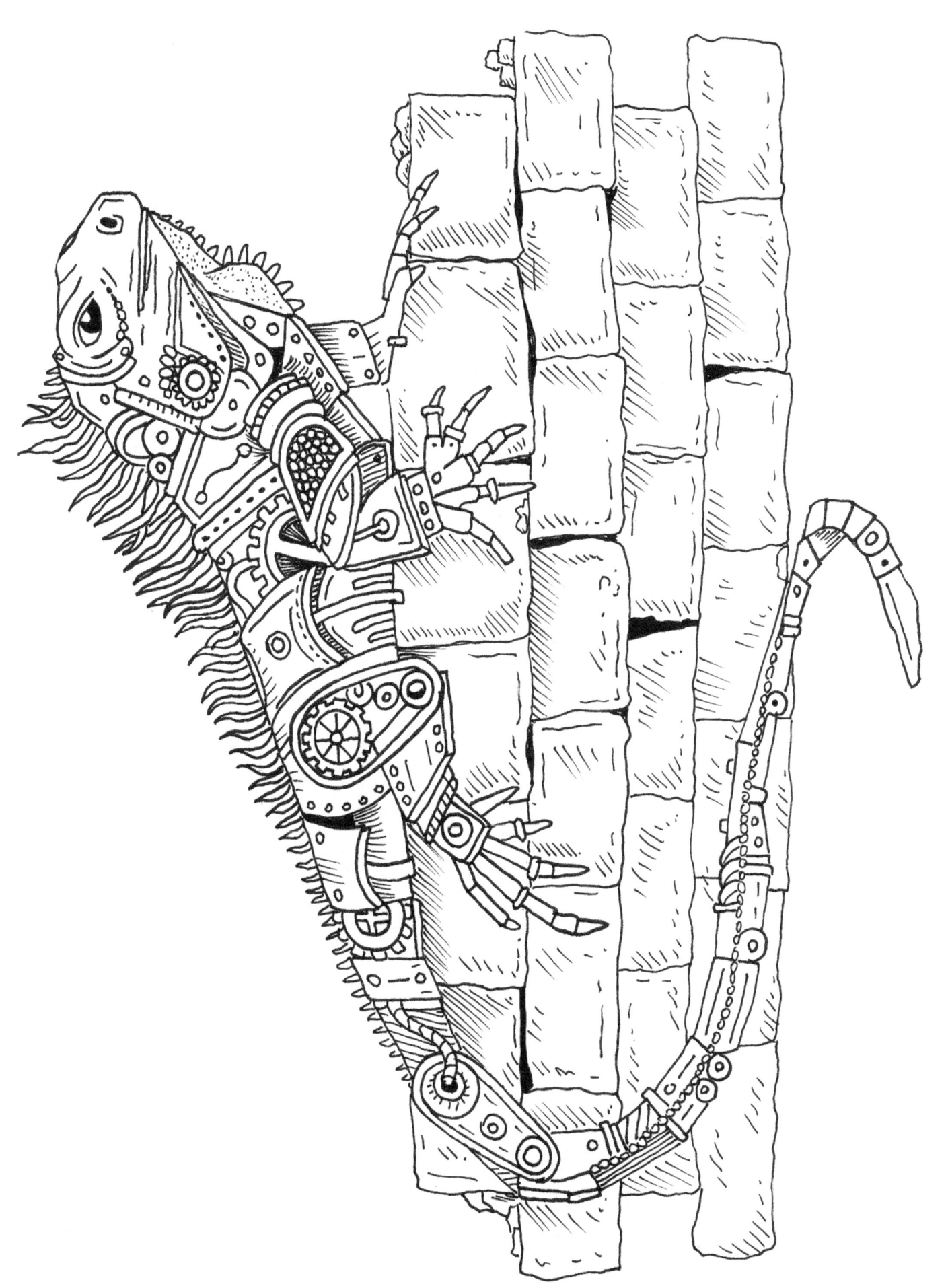

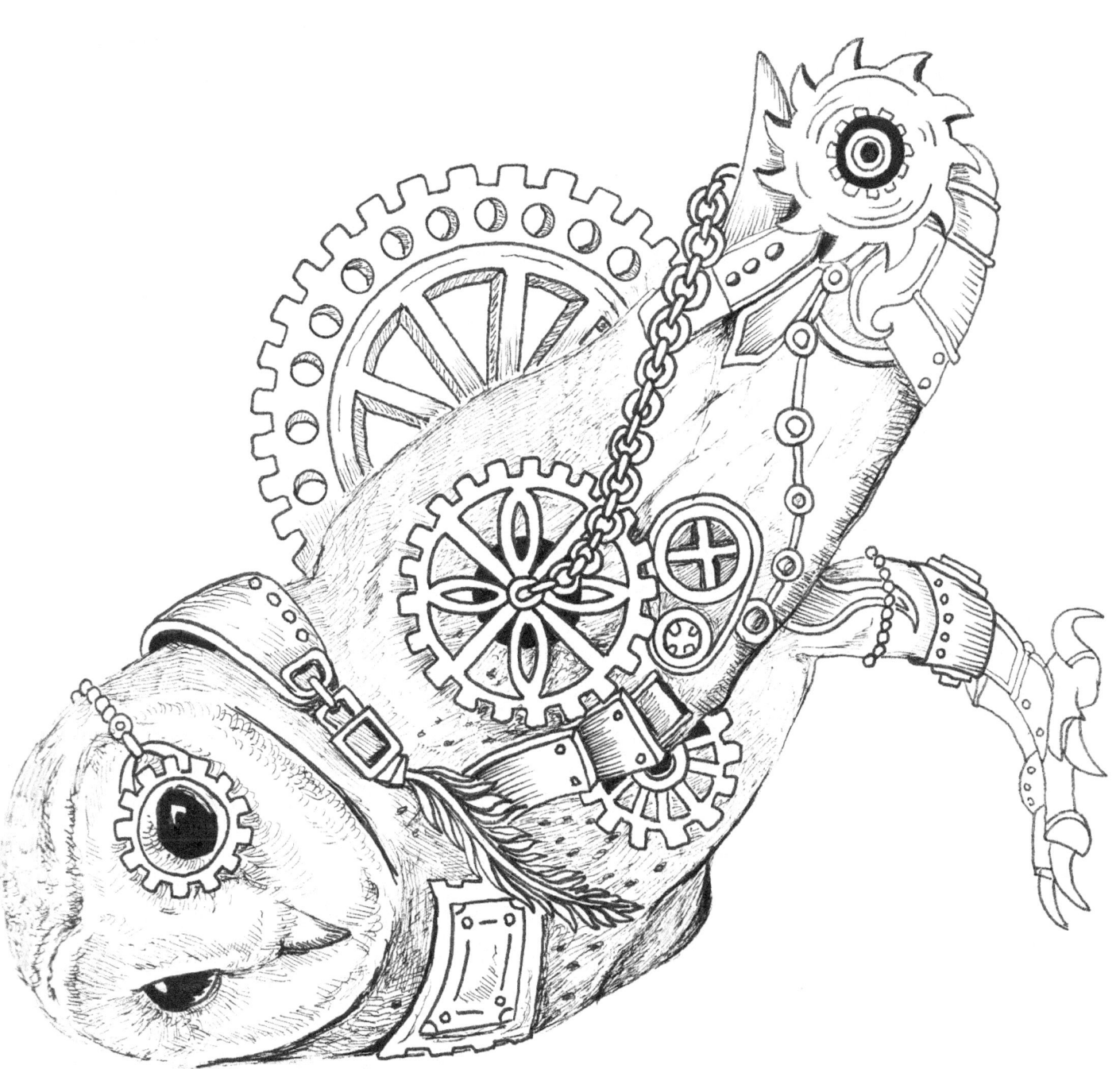

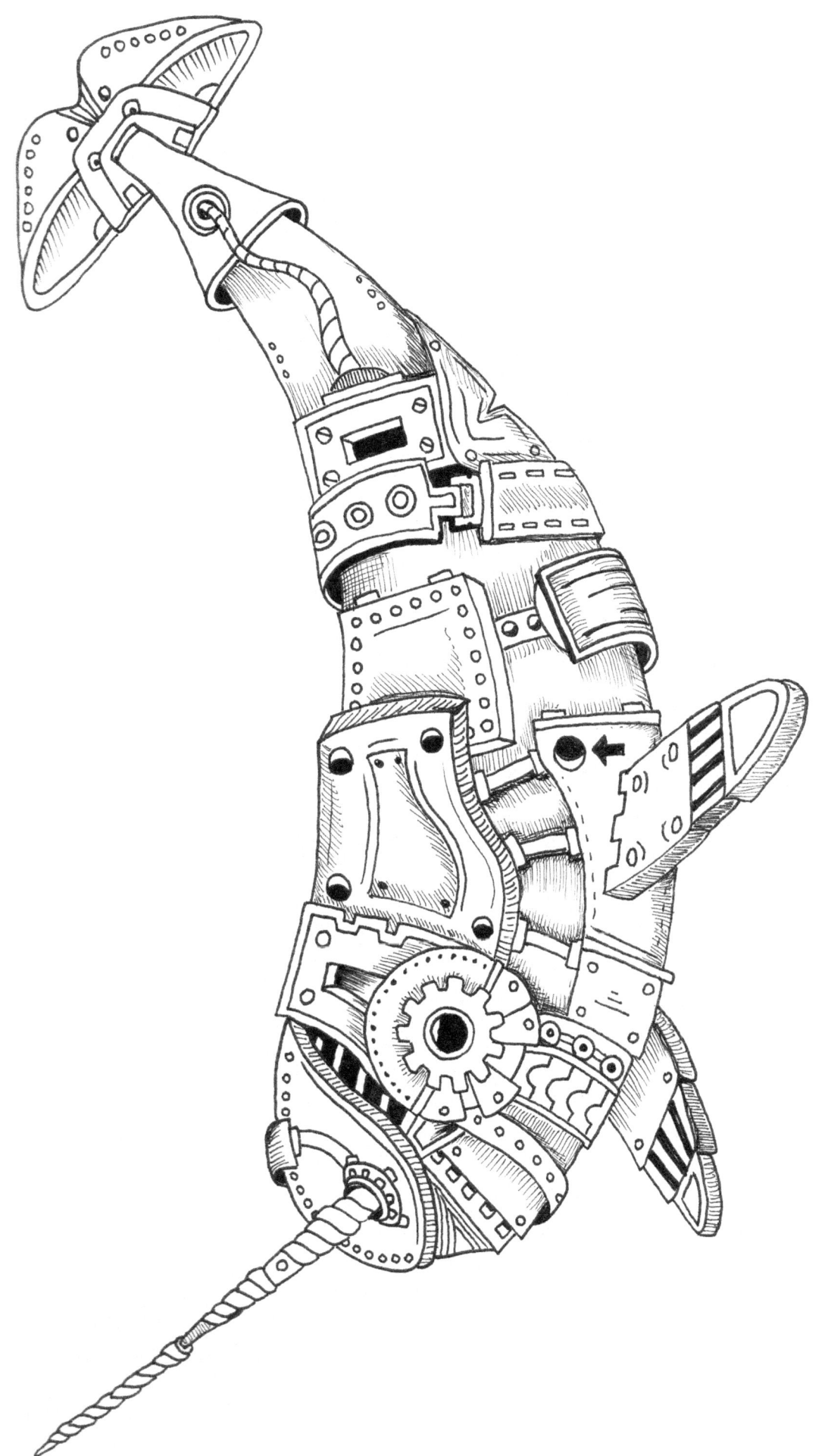

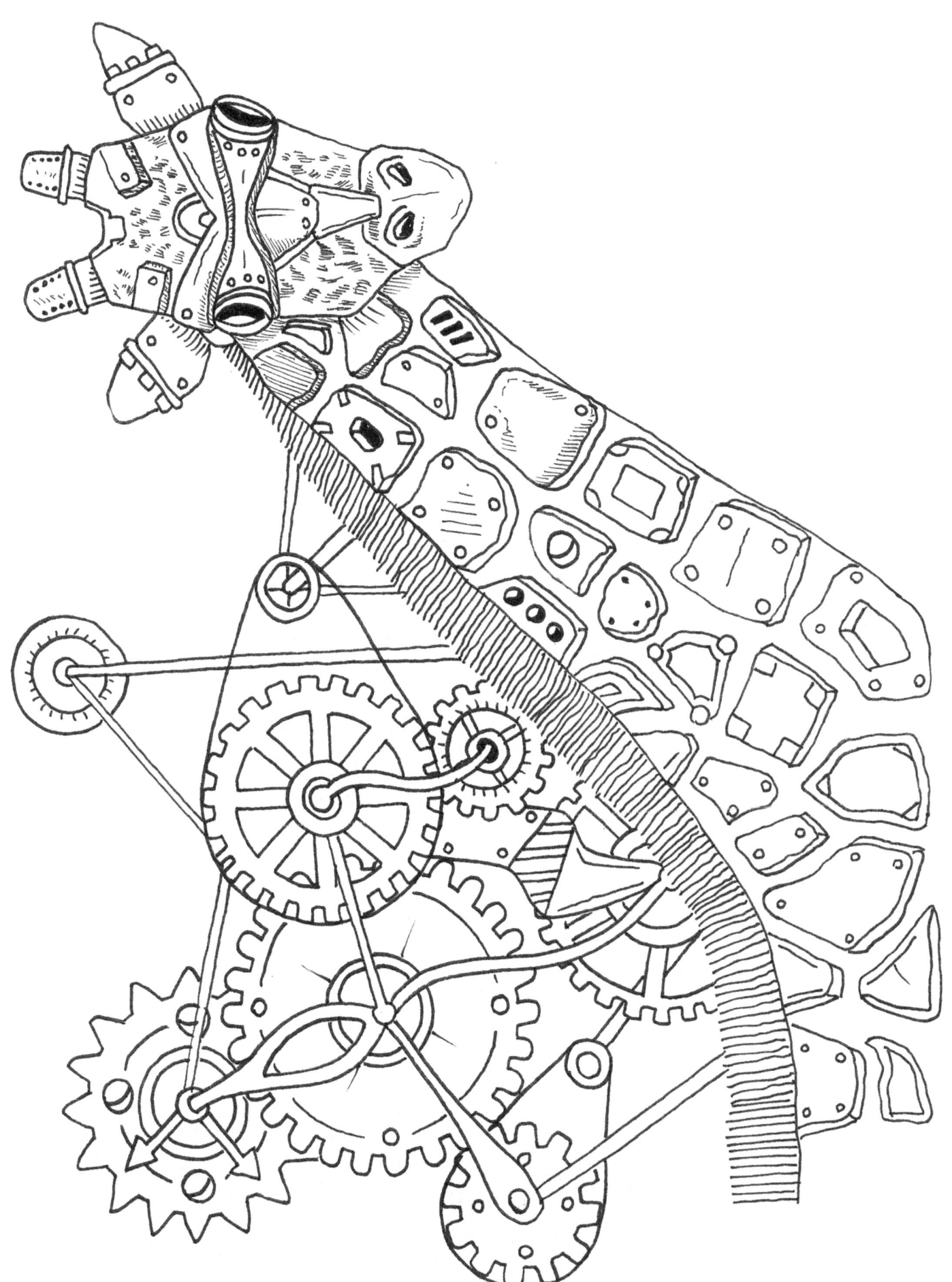

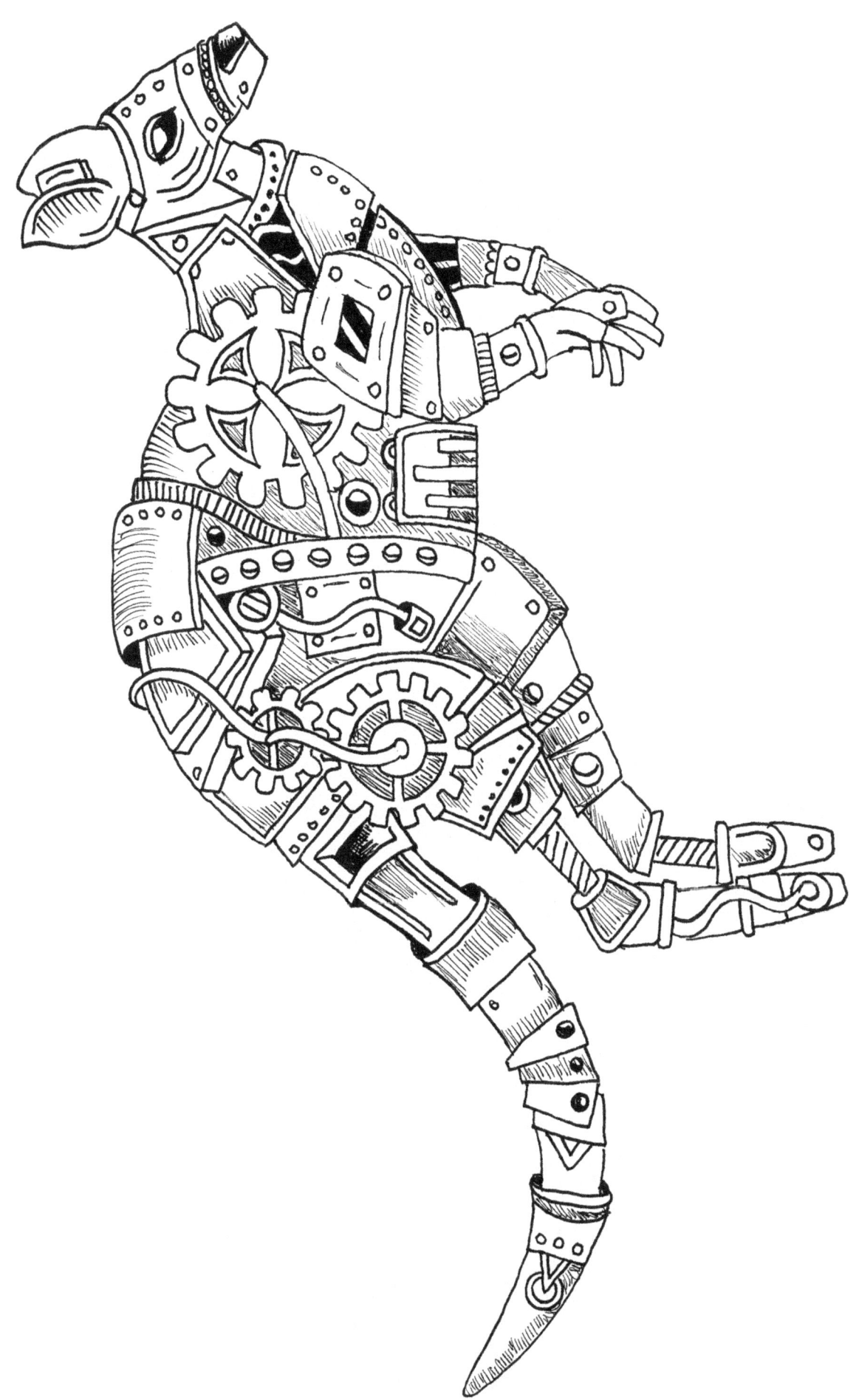

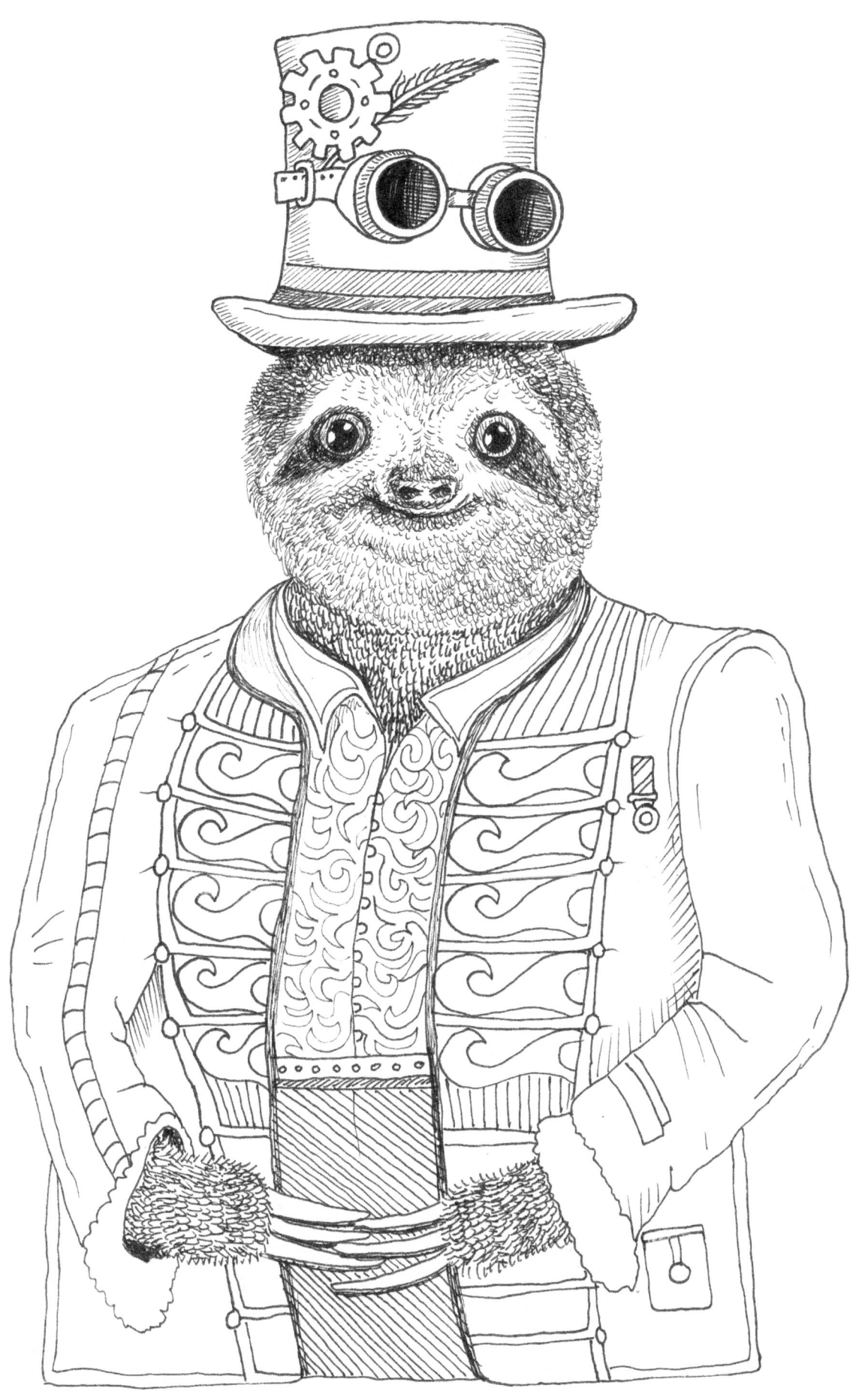

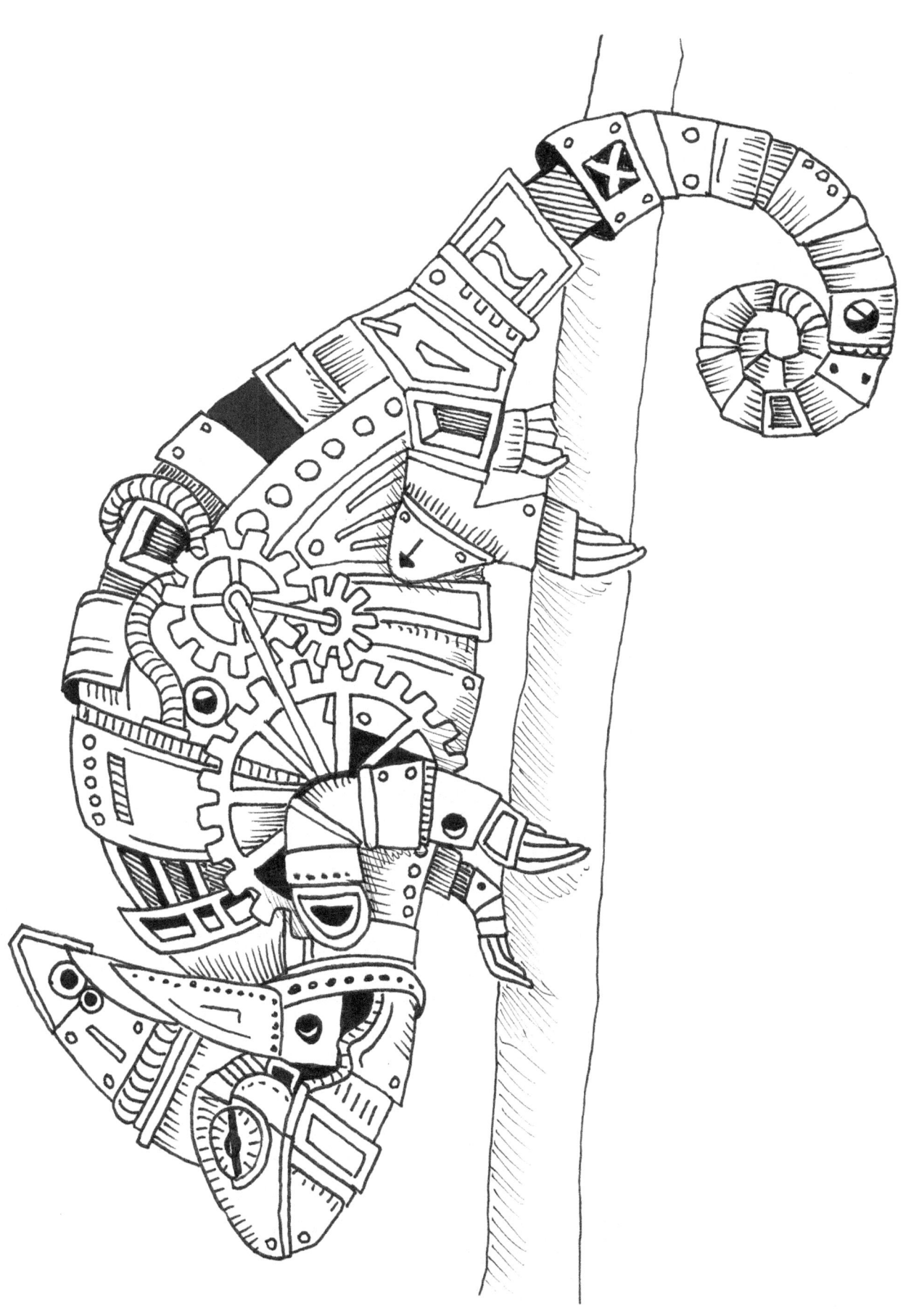

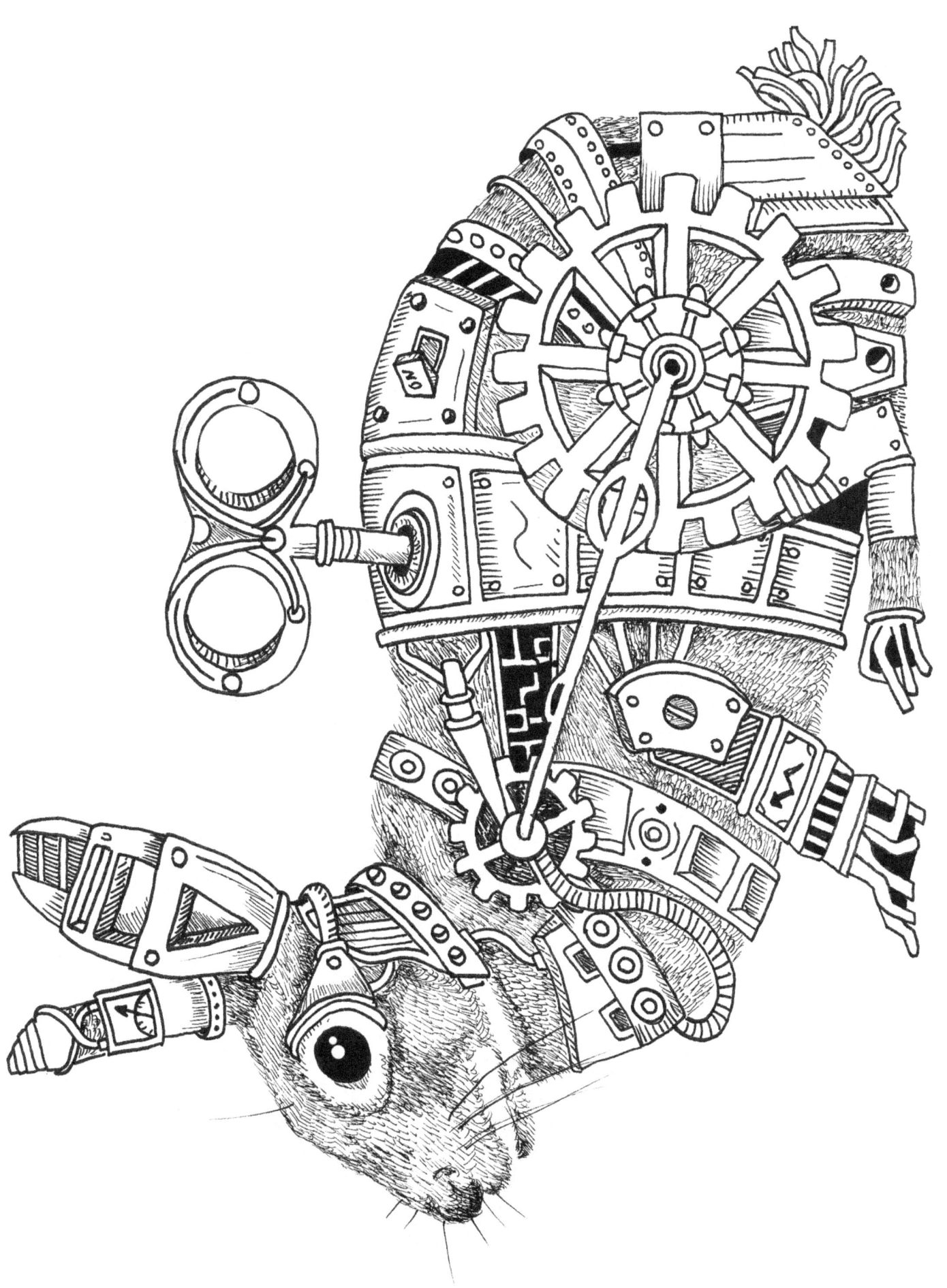

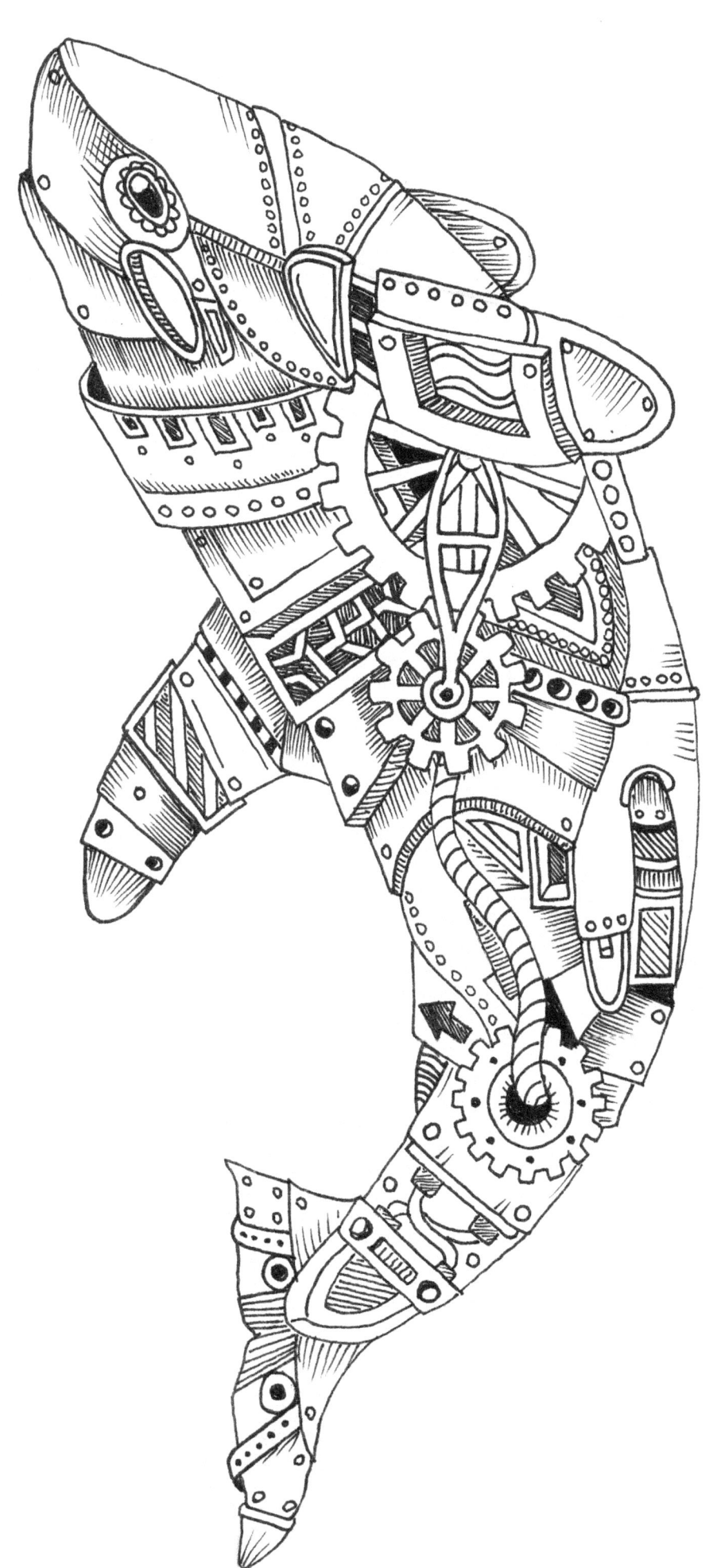

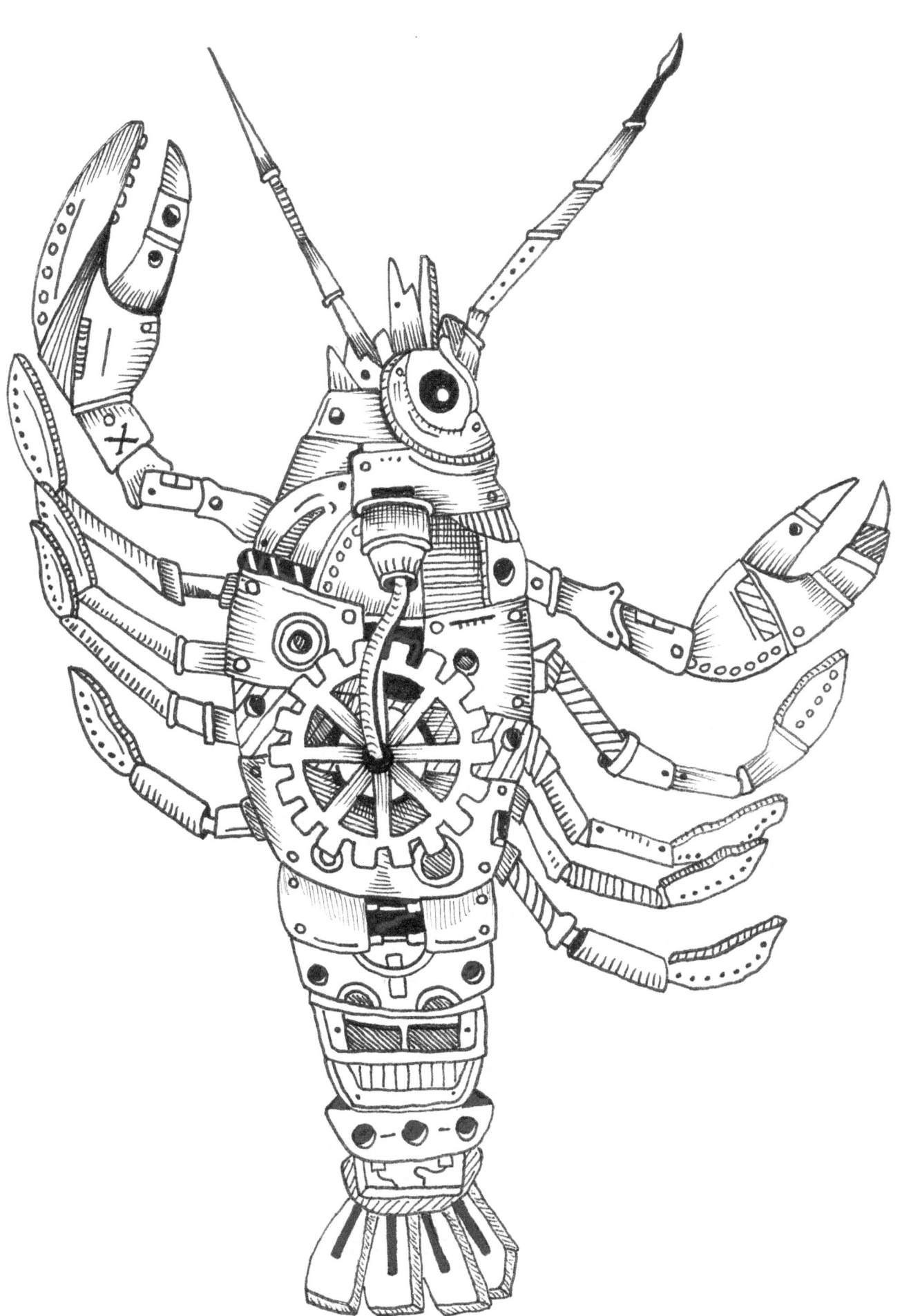

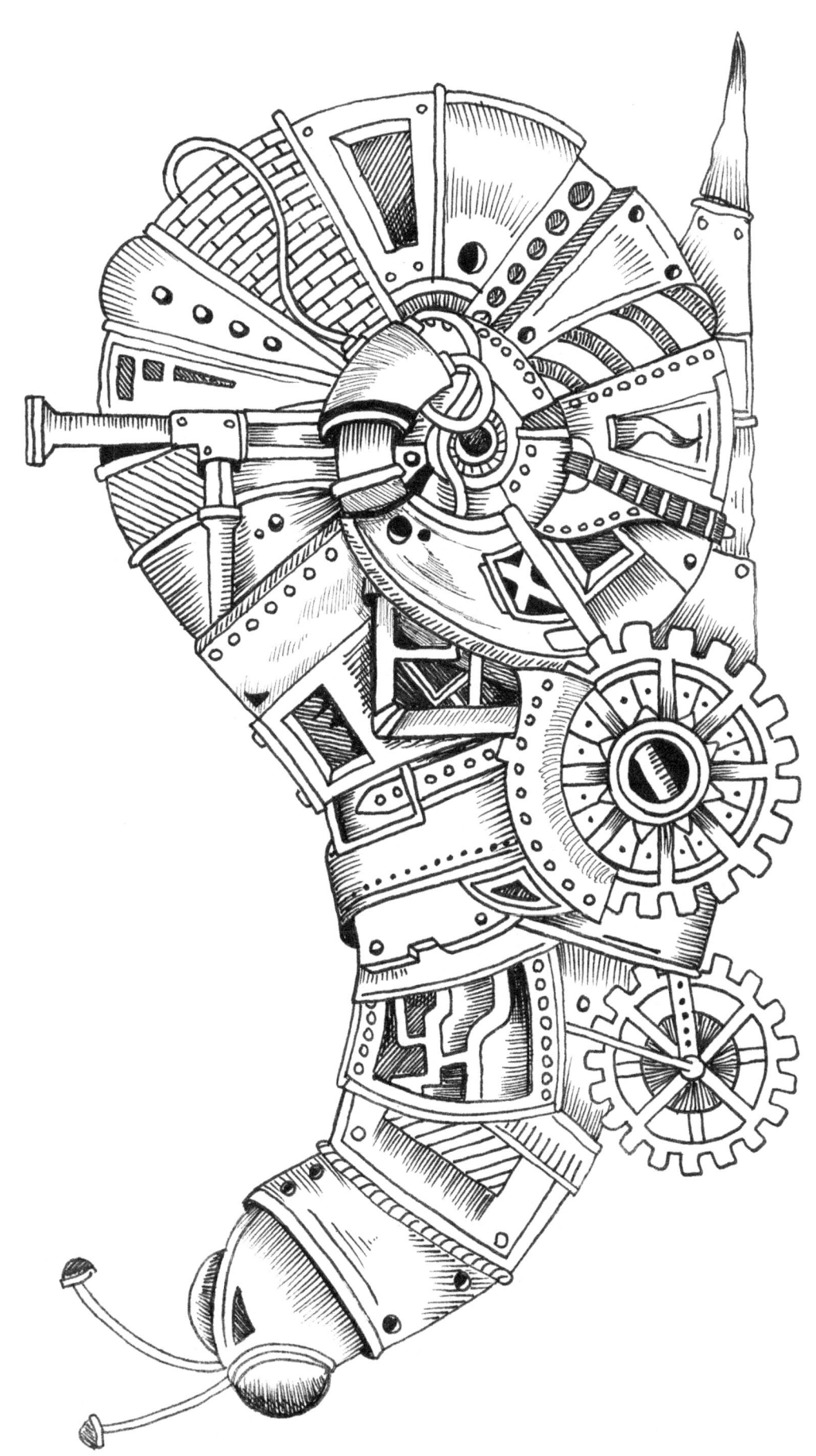

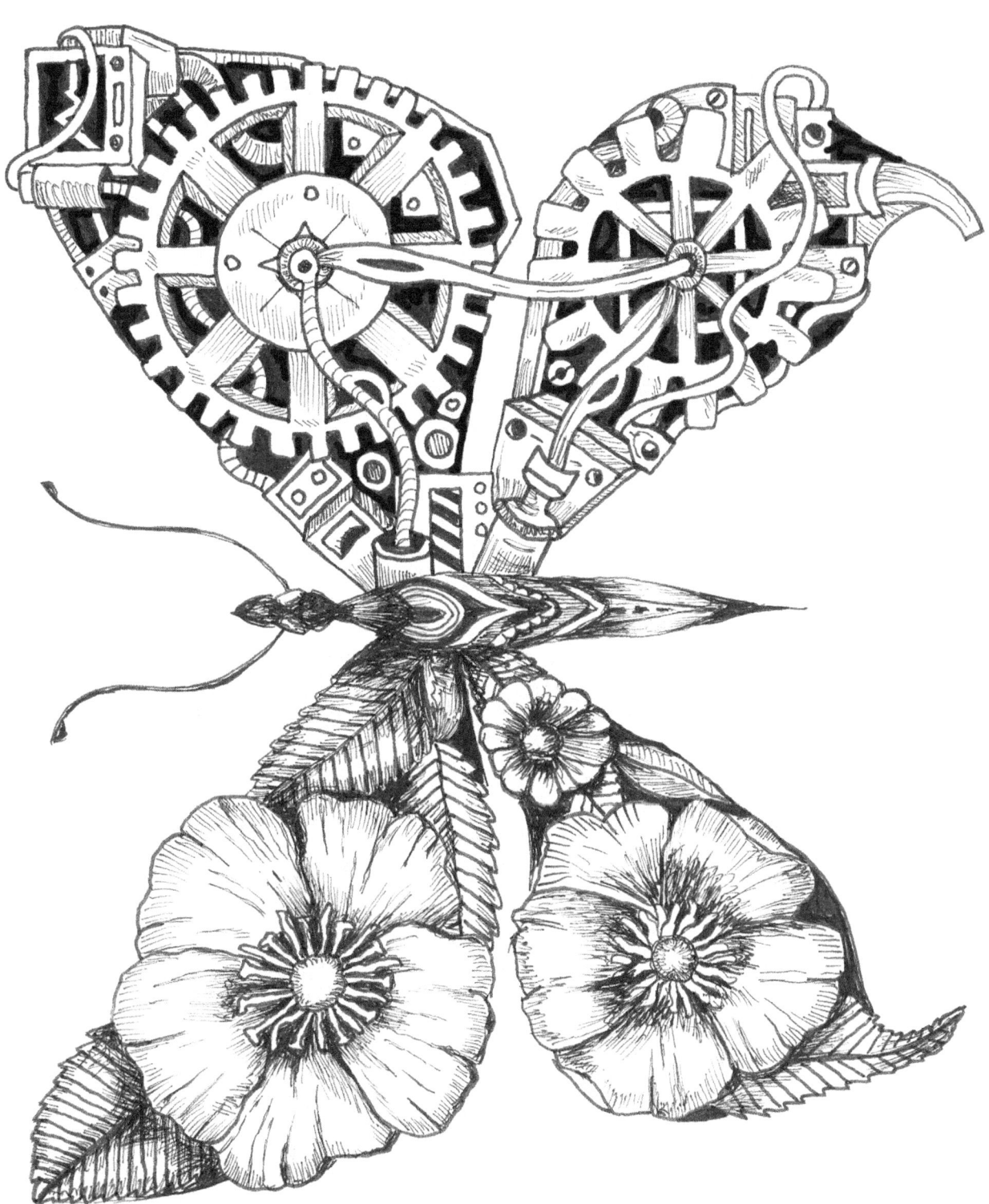

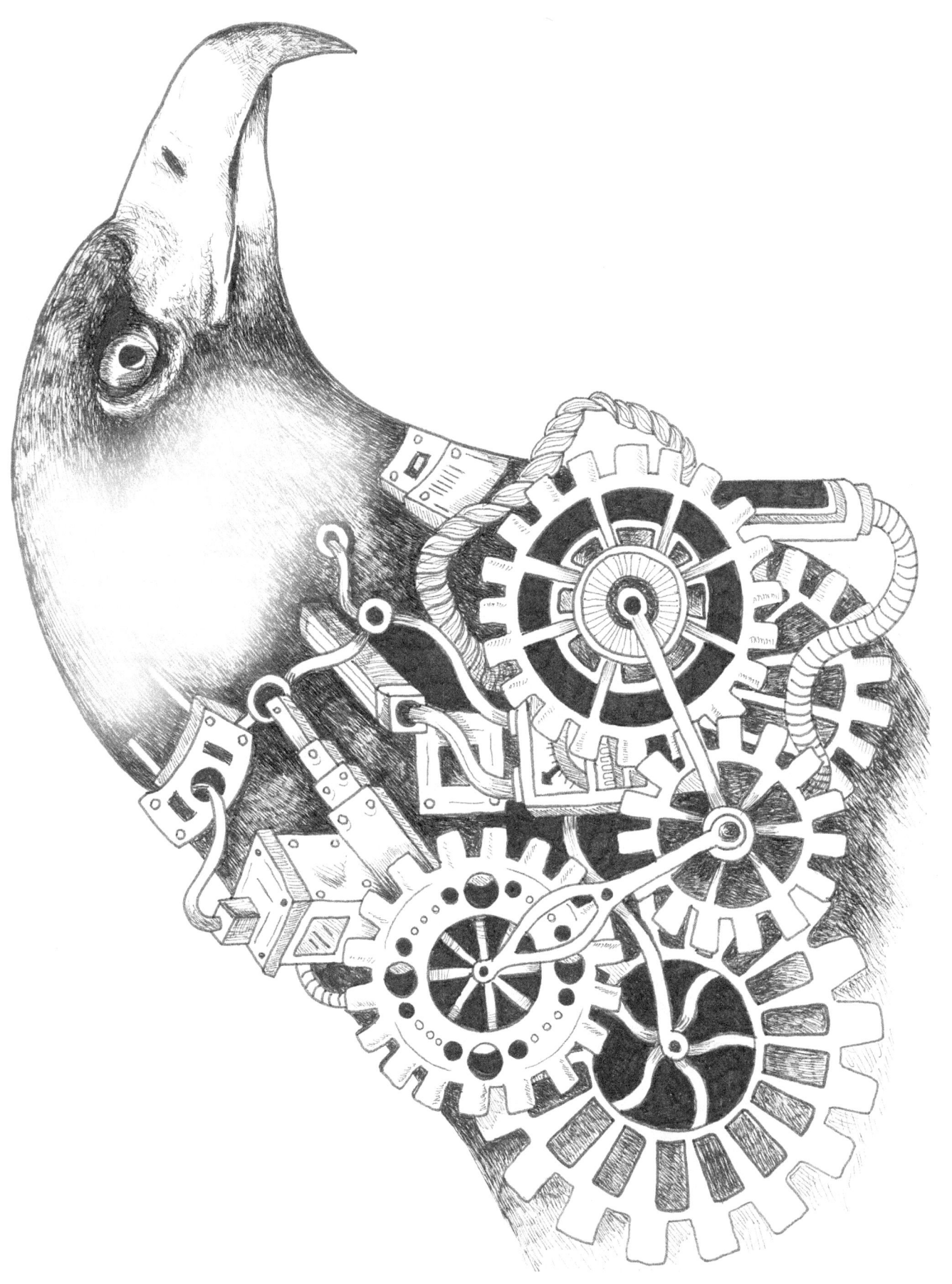

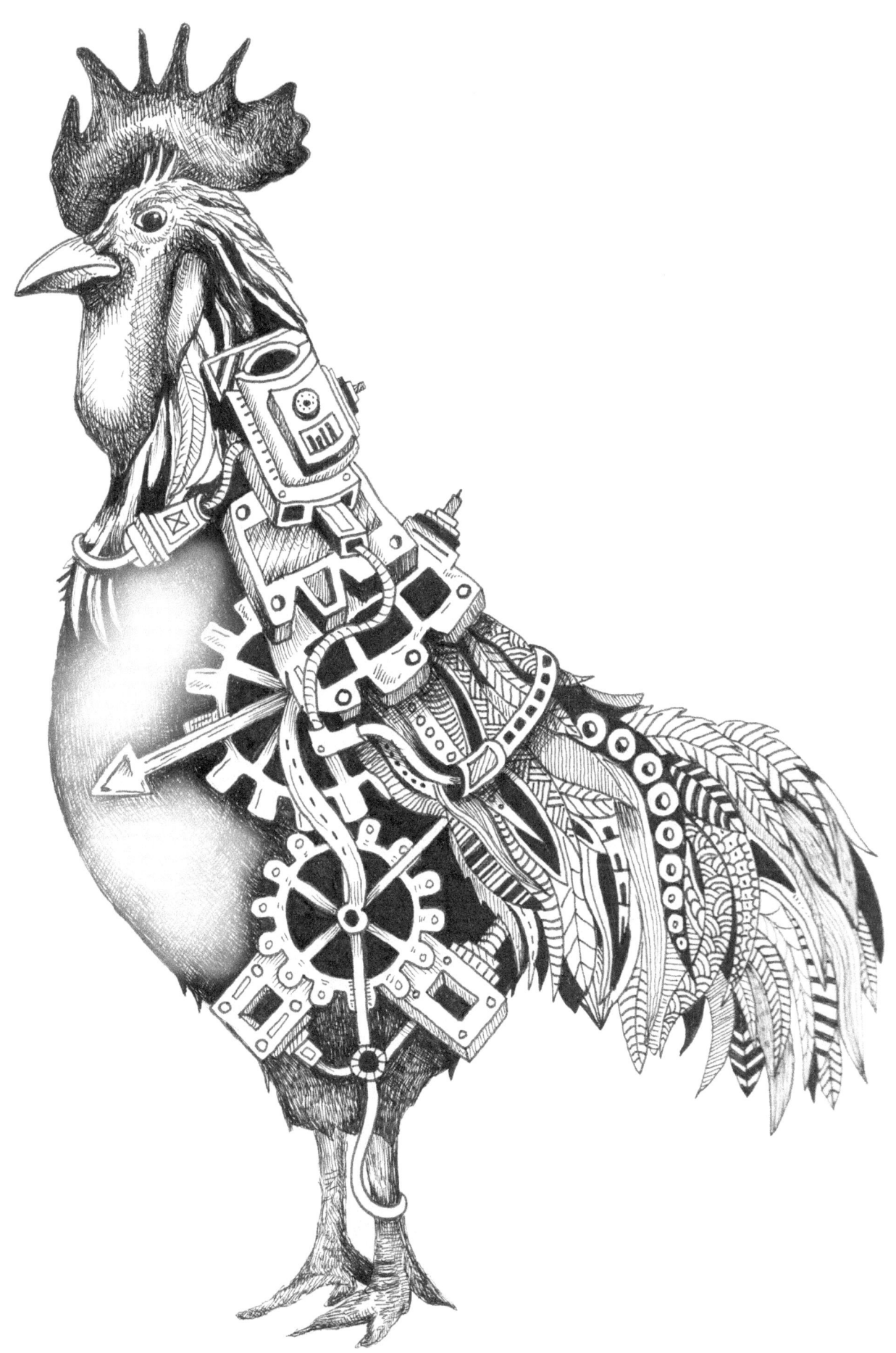

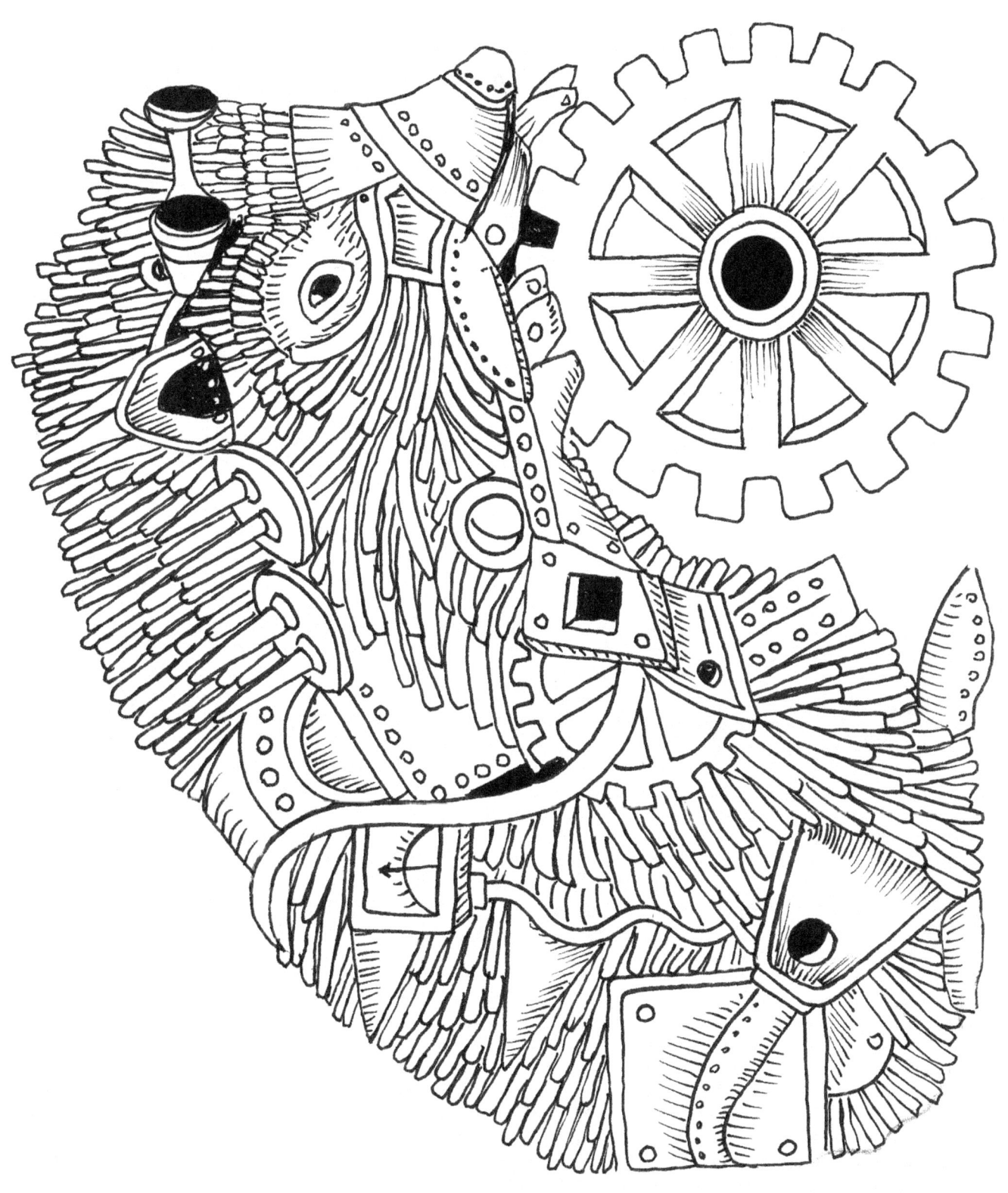

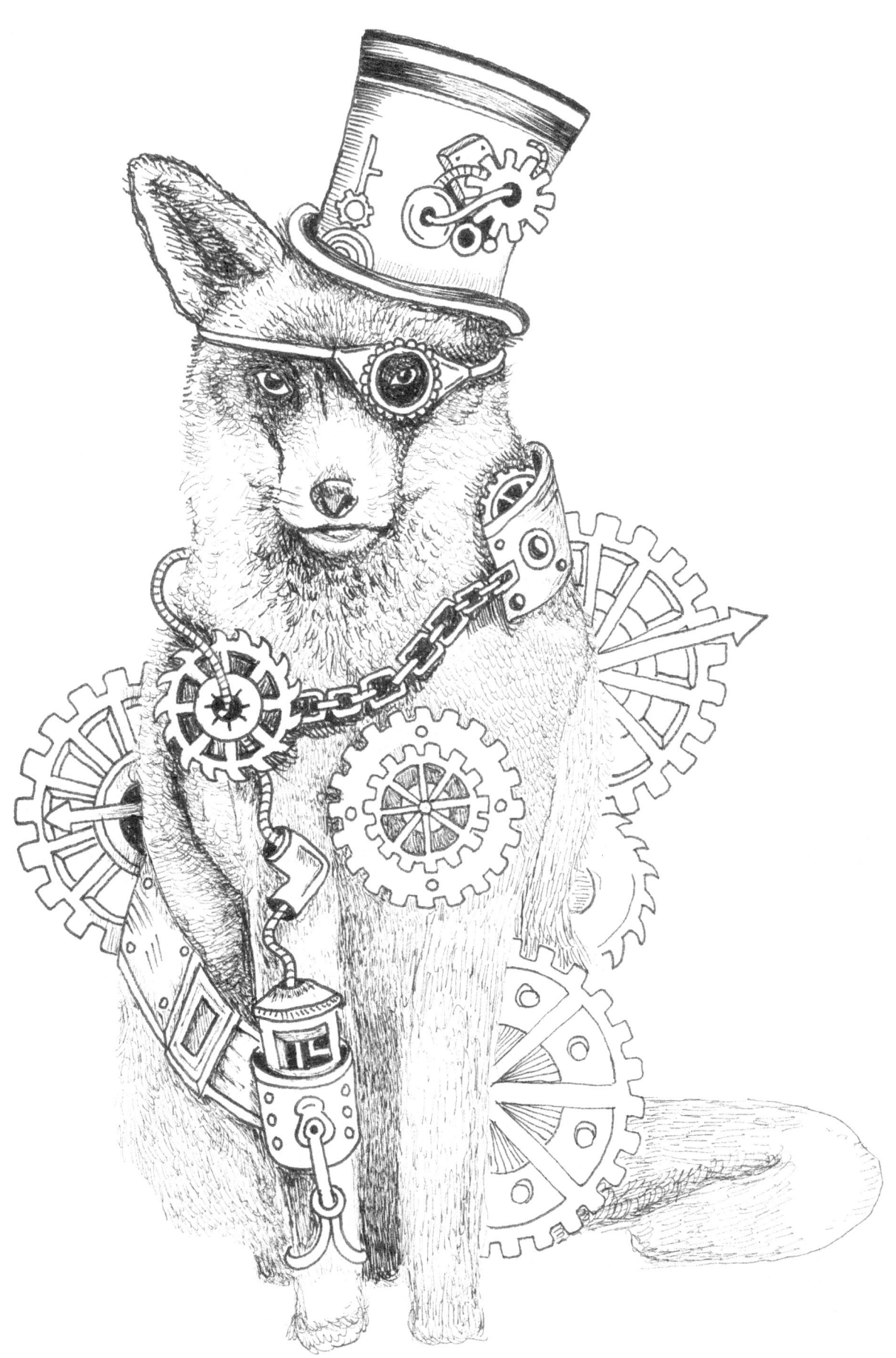

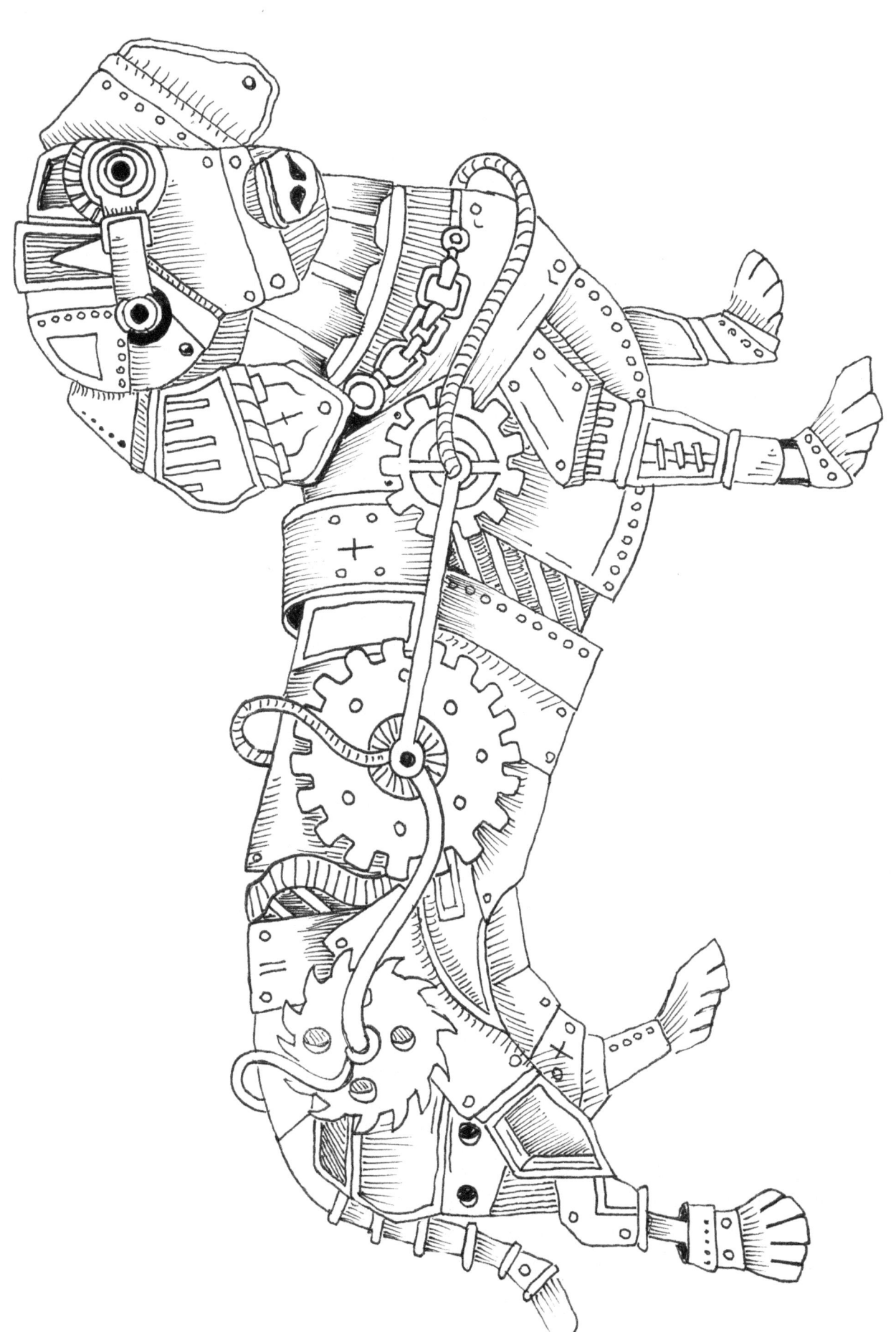

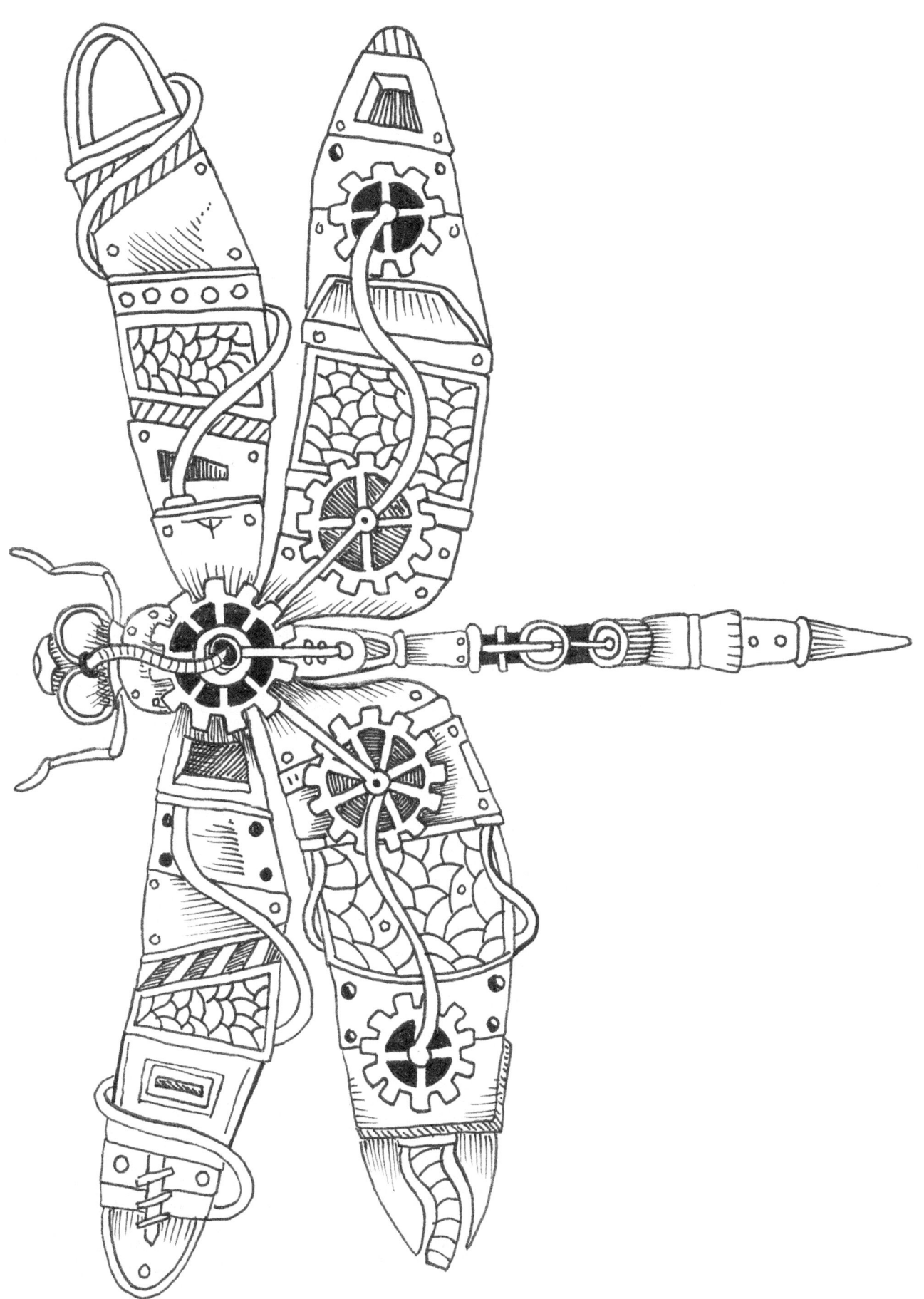

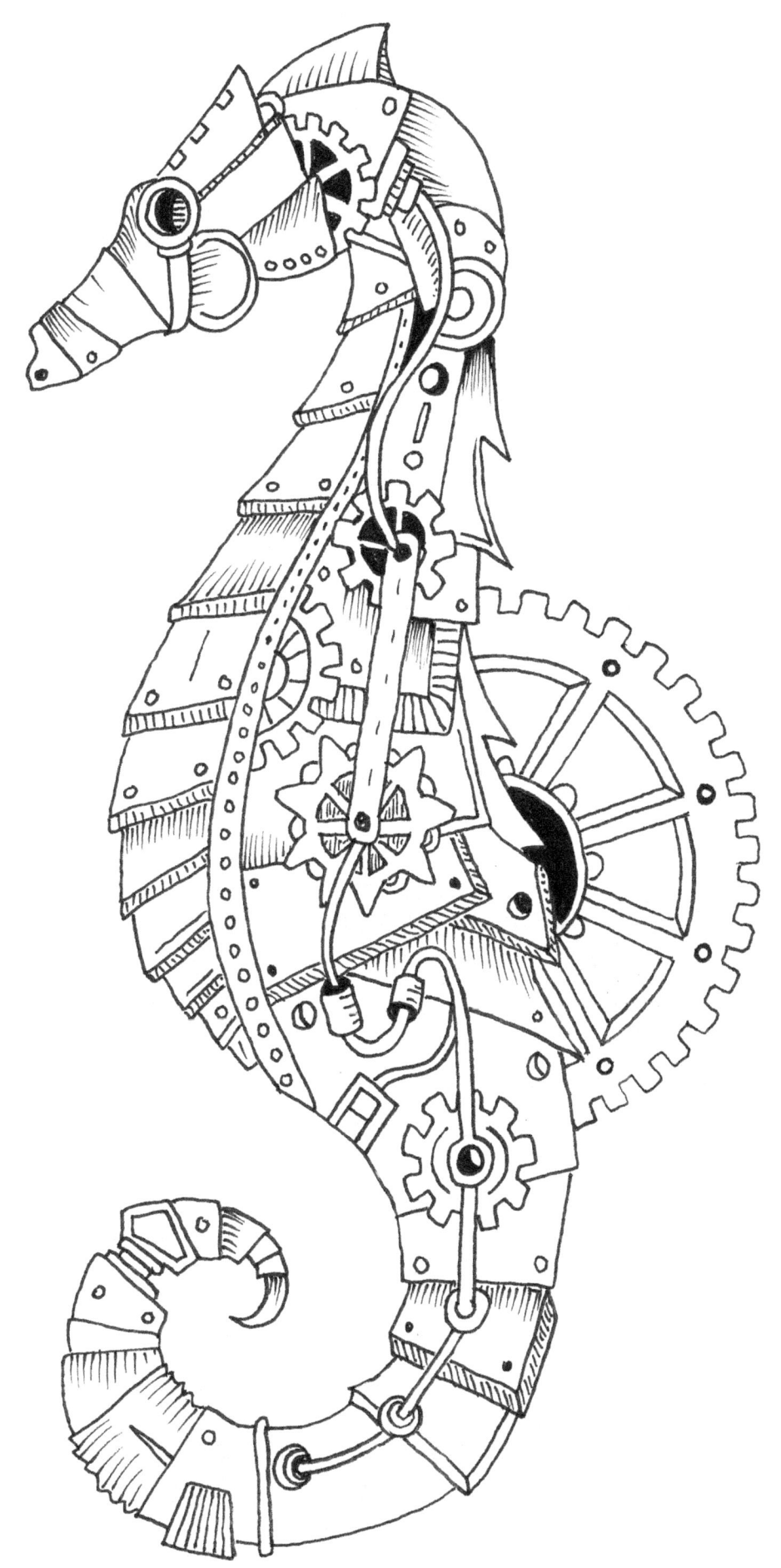

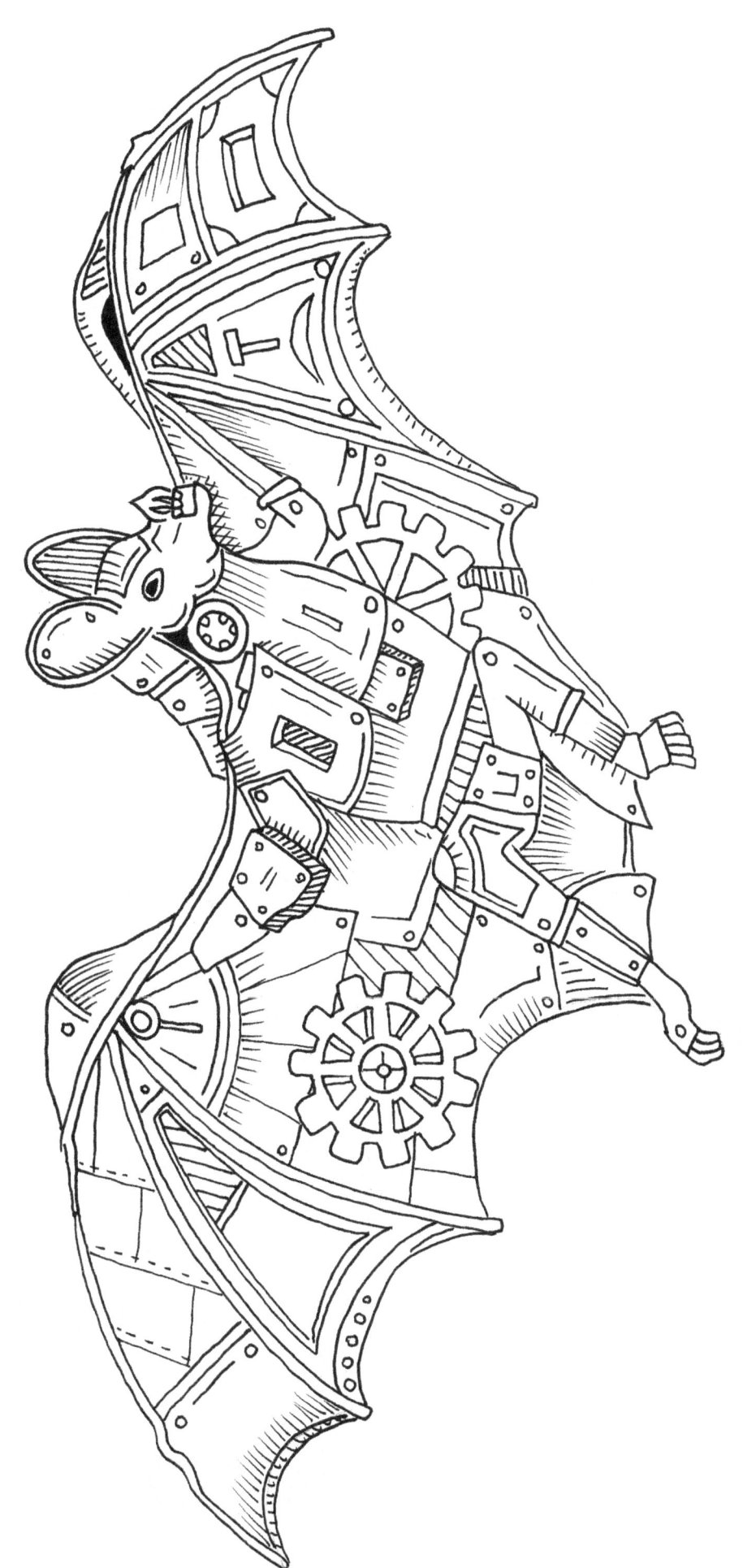

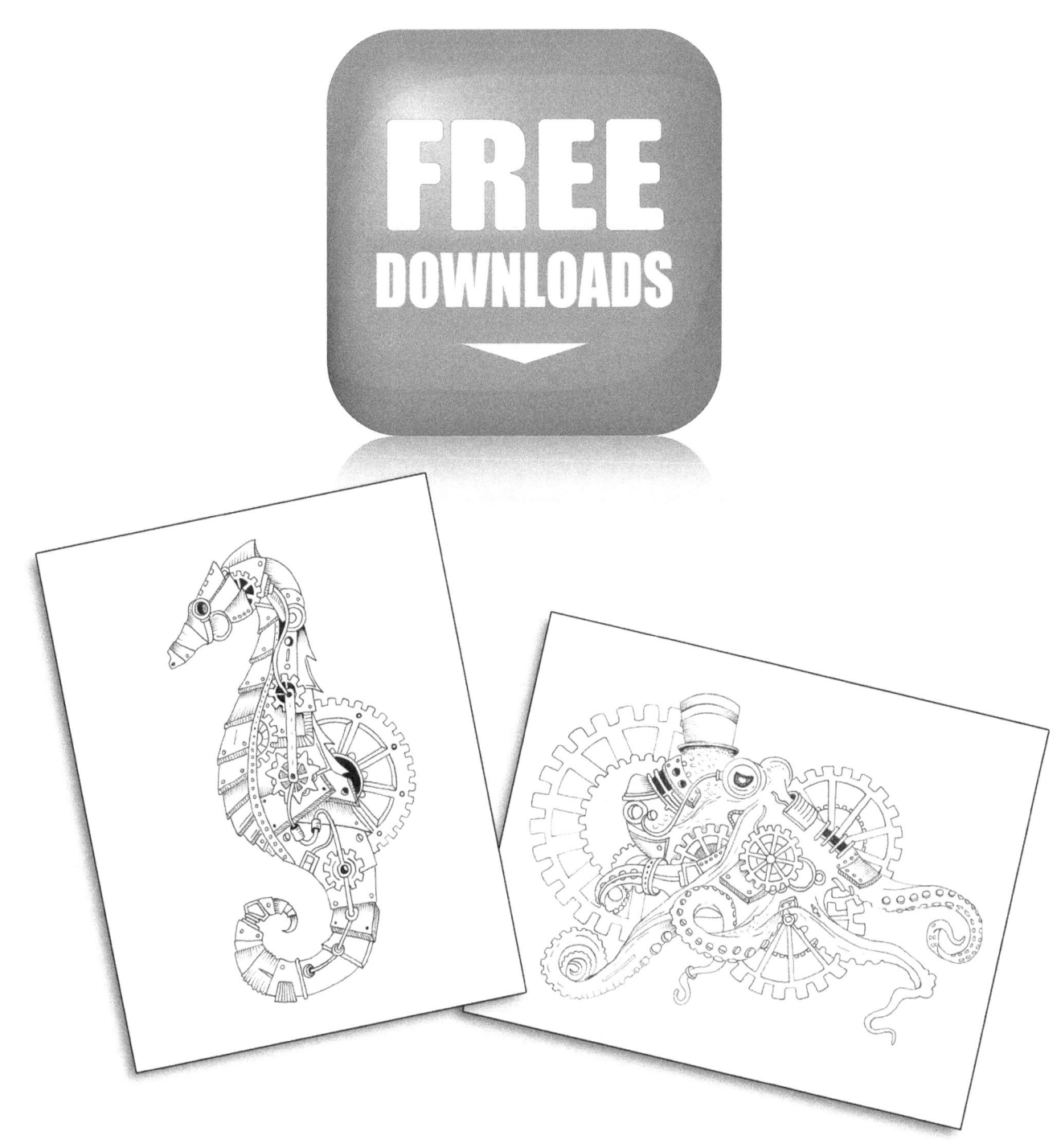

Visit my website **www.squidoodleshop.com** to download the steampunk seahorse and octopus to print out and color again!

...other Squidoodle coloring books available

Search 'Squidoodle' on Amazon!

For original artwork, prints, greetings cards and **FREE** downloads, visit www.SquidoodleShop.com

 Get in touch! www.facebook.com/SquidDoodleArt

www.ingramcontent.com/pod-product-compliance
Lightning Source LLC
Chambersburg PA
CBHW081015170526
45158CB00010B/3051